THE ART OF
Calligraphy &
Lettering

Artwork on the left side and center right side of the front cover, the
back cover, and on pages pages 98-140 © 2011 John Stevens. Artwork
on bottom left corner of the back cover, on pages 9-31, 50-65, and
71-91 © 2006, 2008, 2011 Cari Ferraro. Artwork on top right and
bottom right of the front cover, on pages 34-47, and 93 by Arthur
Newhall and Eugene Metcalf.

Authors: Cari Ferraro, Eugene Metcalf, Arthur Newhall & John Stevens
Associate Publisher: Elizabeth T. Gilbert
Project Editor: Emily Green
Managing Editor: Rebecca J. Razo
Art Director: Shelley Baugh
Production Artists: Debbie Aiken & Rae L. Siebels
Production Manager: Nicole Szawlowski
International Purchasing Coordinator: Lawrence Marquez

Walter Foster

www.walterfoster.com
Walter Foster Publishing, Inc.
3 Wrigley, Suite A
Irvine, CA 92618

Printed in China.
10 9 8 7 6 5 4
18217

THE ART OF
Calligraphy &
Lettering

with Cari Ferraro, Eugene Metcalf, Arthur Newhall & John Stevens

Contents

CHAPTER 1
Calligraphy with
Cari Ferraro

The following chapter provides the perfect start for your journey into the world of calligraphy. With everything from the history of this elegant art form to in-depth instruction on creating each letter of each featured alphabet, accomplished artist Cari Ferraro makes the process of learning calligraphy simple and enjoyable for aspiring artists of all skill levels.

Introduction

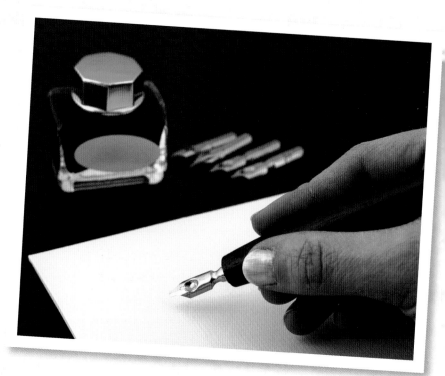

Calligraphy, literally translated "beautiful writing," began as a utilitarian process, but it has evolved into a dynamic and elegant art form. Faced with a world saturated by computer-generated fonts, people are drawn to the more organic handwork produced by a nib. Calligraphy is no longer simply a method for writing formal documents and certificates—it is a means of expressing the emotion and evoking the mood of a word or phrase with strokes, flourishes, and even color. Modern calligraphers are actually expanding the artistic side of writing by experimenting with letterforms, the scrawl, the illegible mark, and varied forms of "word paintings," as well as blending Western calligraphy with Arabic and Asian traditions.

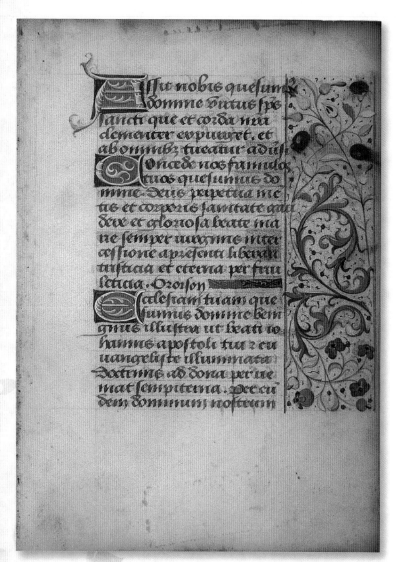

In this chapter, I will introduce you to this thriving art form by giving you a firm grounding in traditional styles of broad pen calligraphy, which will serve as a springboard for your own exploration of letterforms and expressive writing. I define several historical alphabet styles that are made with the broad pen—from the stately blackletter hand to the graceful italic style. I also provide the sequence and direction of each letter stroke, as well as helpful notes and the suggested nib type for each hand. As you learn, it's important to study illustrated books of manuscripts in libraries or on the Internet; viewing these works of art will provide a rich source of inspiration for your own handwork.

Medieval Book of Hours *These lavishly painted prayer books have been called the "bestsellers" of the late Middle Ages, and they represent a high point of calligraphic art.*

History

The beginning of Western calligraphy dates back more than 2,000 years. Early writing was done with brushes as well as with reed and quill pens, and calligraphers, or "scribes," used stone, clay tablets, papyrus, and animal skins as writing surfaces. Our modern alphabet has its roots in ancient Rome, where early inscriptions in stone feature all the capital letterforms we recognize today.

During the medieval era, manuscripts, which had been previously copied only by monks, began to be produced in professional workshops. Trained scribes executed the calligraphy, and illumination artists added decorations and gilding (or gold leaf). As reading became more common, demand for personal prayer books increased. Thousands of copies of the devotional *Book of Hours* were made, and many pages from these books can still be found at antiquarian book markets.

In the 15th century, the invention of the movable type printing press eliminated the need to copy books manually, so calligraphy soon fell into general disuse. But the printing press also was responsible for elevating calligraphy to a specialized art form, encouraging scribes to refine their skills and develop instruments that could match the intricacy produced by engravers of copper printing plates. The elaborate flourishes and fine handwork of the copperplate style continued through Victorian times.

The modern revival of calligraphy was sparked in the early 20th century during the Arts and Crafts Movement. There are calligraphers teaching today who can trace their "lineage" back to teachers such as Edward Johnston and Rudolph Koch. During the 1970s, Donald Jackson, scribe to the Queen of England, conducted workshops in the United States that generated intense interest in calligraphy. Inspired by his visit, lovers of the art form founded a number of guilds that continue to be active today. Now there is even an international community of Internet calligraphers called "Cyberscribes," which began in the 1990s.

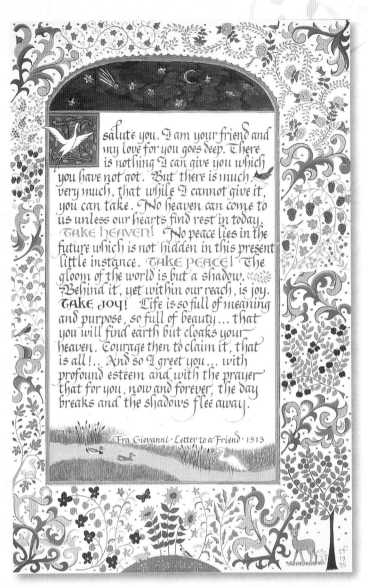

Looking to the Past *This is my study of Fra Giovanni's famous historical manuscript, "Letter to a Friend." You will notice that I adapted the border from the illumination used on the Book of Hours (see page 8) to create this piece of artwork.*

9

Tools & Materials

Drawing materials needed for calligraphy, such as pencils and a ruler, are probably as close as your desk. You'll find all the calligraphy tools you need, including dip pens, which produce sharp, clean lines and allow you to easily change nib sizes, at your local arts and crafts store. Investing in high-quality materials will make your learning experience more enjoyable.

Basic Calligraphy Supplies

Nibs

Nibs (also called "points") are writing tips that are inserted into the end of a pen holder. Nibs come in a variety of shapes and sizes, depending on the task they are designed to perform—each releases the ink differently for a unique line quality. For example, the italic nib has an angled tip for producing slanted letters, whereas the roundhand nibs feature flat tips for creating straight letters. Keep in mind that nib numbers can vary in size from brand to brand.

| #2-1/2 italic nib | Drawing nib | #4 roundhand nib | #2 roundhand nib | #1 roundhand nib |

Ink

Non-waterproof black carbon ink is the best ink to use for basic lettering. Many fountain pen inks and bottled, colored inks are dye-based and will fade quickly, so it's best to use gouache for adding color. (See "Illumination Supplies," page 11.)

Reservoir

A reservoir (pictured at right) is a small metal piece that slides over the nib to help control the flow of ink from the nib for smooth writing. Each brand of nib will have its own particular reservoir.

Pen Holder

The broad end of a pen holder has four metal prongs that secure the nib. The tool should be held like a pencil, but always make sure to hold it so that the rounded surface of the nib faces upward as you stroke.

Paper

Hot-pressed (smooth) watercolor paper is a great choice for general lettering, whereas cold-pressed (medium) watercolor paper is ideal for illumination projects. You will want to have a supply of practice paper, such as layout bond or translucent paper, that you can place over guidelines or graph paper. Printmaking paper and other fine art papers may also be used. With all fine-grade papers, keep in mind that the paper needs the right amount of sizing (a coating that makes the paper less absorbent) to work well for lettering. Too little sizing will cause the ink to spread; too much will cause the ink to sit on top of the paper.

Illumination Supplies

Gouache

Designer's gouache (pronounced "gwash") is similar to watercolor paint, but it contains more filler, which makes it opaque. It can be thinned to a consistency suitable for flowing from a nib. You can use the primary colors (red, yellow, and blue) alone, or you can mix them together to create almost any other color. Use gold gouache to add gilded accents that mimic the brilliance of gold leafing. (See "Illumination with Cari Ferraro," page 48.)

Paintbrushes

To mix your colors, load or fill the pen, and paint large areas, purchase a large round paintbrush. Also purchase a small round brush for painting fine details. Round paintbrushes have tips that taper to a point—this shape allows the bristles to hold a good amount of moisture while maintaining the ability to produce fine lines. Before you paint, be sure to dampen your brush so that the ink or paint slides off the bristles easily.

Palette

A white ceramic palette with several wells will be handy when you mix colors. The wells allow you to keep an array of thinned and mixed colors handy and prevent the colors from running together. A palette with a large center well provides a convenient place to hold clean water for adding to mixes in other wells.

Drawing Supplies

Pencils

You will need pencils of varying hardness, indicated by grades (a letter and usually a number). H pencils have hard leads—the higher the number, the greater the hardness. These pencils are best for producing fine, light lines, but be aware of the amount of pressure you apply; it's easy to score the paper. B pencils have softer leads—the higher the number, the greater the softness. These pencils produce darker lines with less pressure. HB pencils are midway between hard and soft grades and are great for general purpose drawing. Use a carpenter's pencil to practice drawing very thick and thin strokes.

Other Supplies

A drawing board, T-square, and triangle with a 90° corner will make ruling guidelines fast and easy. If you don't have a T-square, a cork-backed metal ruler will work. The following items also are useful: tracing paper for transferring letters and designs, a white vinyl eraser, low-tack or artist's tape, a jar of water, a large flat paintbrush, and a soft rag for wiping nibs. Paper towels also are helpful for keeping your work area clean and wiping your hands to avoid smudges on your work. Keep a pad of damp paper towels in a flat dish near your work, so you can wipe your fingers often to avoid transferring the inevitable ink smudges to your calligraphy; an alternative that works wonders on ink and paint is plain baby wipes.

Assembling the Pen

Calligraphy pens are simpler than they appear. Their design is centuries old, and need not be improved upon. They consist of a handle, nib, and reservoir (which can be removed for easy cleaning). Most handles are a standard size, but it is a good idea to purchase your nibs and pen holder from the same manufacturer to ensure that they will fit.

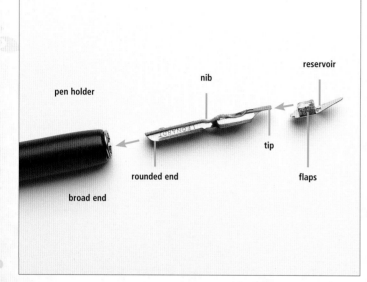

Parts of the Pen *The photograph above shows the three components needed to assemble the pen: the pen holder, the nib, and the reservoir. As indicated by the arrows, the nib slides into the pen holder, and the reservoir slips over the nib.*

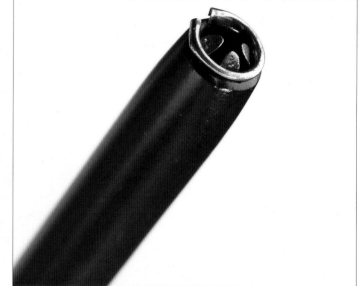

The Pen Holder *The pen holder grips the nib with four metal prongs. These prongs are made of thin metal and can be manipulated to better hold the nibs after they warp from use. Gently press the prongs toward the outer ring of the pen holder for a tighter fit.*

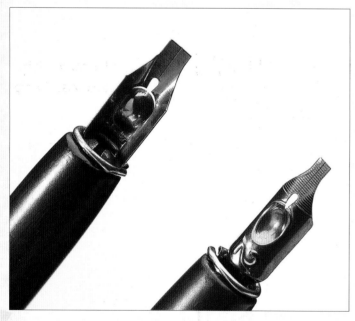

Inserting the Nib *Slide the rounded end of the nib into the area between one of the metal prongs and the outer ring of the pen holder until it fits snugly and doesn't wobble. If your nib wiggles, remove it, rotate the pen holder a quarter turn, and again slide in the nib. The pen at left shows the nib from beneath, and the pen on the right shows the nib from above.*

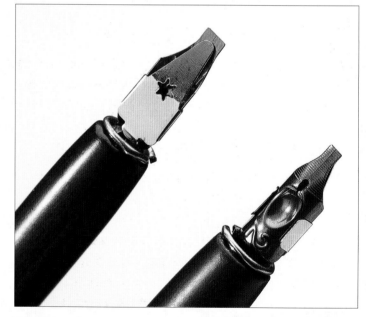

Attaching the Reservoir *The gold-colored reservoir slips over the nib, cupping the underside to create a "pocket" for the ink and touching the nib near the tip to control the ink flow (left). The two flaps of this piece slide over the sides of the nib, as shown on the right. (Note that the drawing nib comes with an attached reservoir.)*

TIP

Left-handed scribes can give a roundhand nib an opposite angle by grinding the tip on a sharpening stone. Specially made left oblique nibs are also available through mail-order and online art supply dealers.

Work Area Setup

Arranging Materials

Right-handed scribes using a dip pen should place everything on the right; however, when filling a pen with a brush, your palette or ink should be on the left. Left-handed scribes should reverse the position of the materials.

Right-handed Scribes

Left-handed Scribes

Developing Good Habits

To maintain your comfort level, take frequent breaks to relax your hands, back, and eyes. As you are lettering, move the paper from right to left to keep your working hand centered in front of your eyes. Clean your pen by dipping just the tip of the nib in water and wiping it dry, even if you're just stopping for a few minutes.

Preparing the Board Surface

Tape a few sheets of blotter paper, newsprint, or paper towels to the board to form a cushion under the paper. This gives the pen some "spring" and will help you make better letters. You also can work on top of a pad of paper for extra cushion. To protect the paper, place a guard sheet under your lettering hand, or wear a white glove that has the thumb and first two fingers cut off. This protects the paper from oils in the skin, which resist ink.

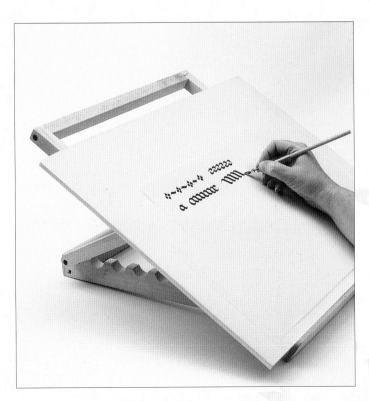

Positioning the Work Surface

A sloping board gives you a straight-on view of your work, reducing eye, neck, and shoulder strain. The work surface affects the flow of ink—on a slant, the ink flows onto the paper more slowly and controllably. To prevent drips during illumination, you will need to work on a relatively flat surface. Practice lettering at different angles.

Getting Started

D ip pens require a little preparation and maintenance, but when properly handled, they are long-lasting tools. Before you jump into writing, you'll need to learn how to assemble, load, manipulate, and clean a dip pen. Have a stack of scrap paper handy, and take time to become familiar with the unique character of the marks made by each nib.

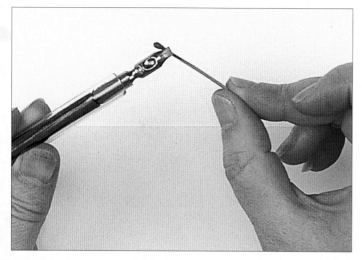

Preparing New Pen Nibs *New nibs are covered with a light coating of oil or lacquer and need preparation to make the ink or paint flow properly. Wash new nibs gently with soapy water, or pass the tip of the nib through a flame for a few seconds, as shown; then plunge it into cold water.*

Adjusting the Reservoir *After slipping the reservoir onto the nib, adjust it (using fingers or pliers) so that it's about 1/16" away from the tip (too close interferes with writing; too far away hinders the ink flow). If it's too tight, you'll see light through the slit while holding it up to a light source.*

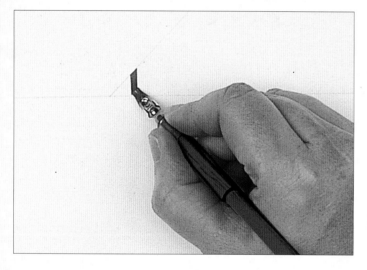

Understanding Pen Angle *The angle of the flat end of the nib to a horizontal line is known as the "pen angle." It determines the thickness of the line as well as the slant of stroke ends and serifs (small strokes at the end of letters). For most lettering, you'll use an angle of 30° to 45°.*

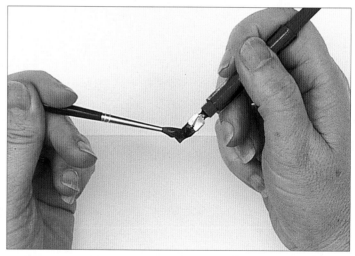

Loading the Pen *It is best to use a brush or dropper to load the nib; if you dip your nib into the ink, you are more likely to start every stroke with a blob of ink. Regardless of how you load your pen, it's always a good idea to test your first strokes on scrap paper.*

TIP

If you choose to dip the nib rather than load it with a brush, hold the nib against the side of the palette well (or ink bottle) to drain off the excess after dipping.

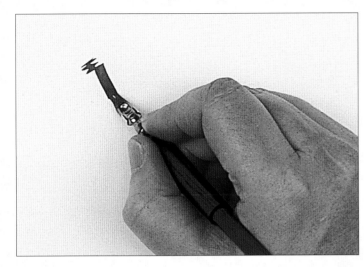

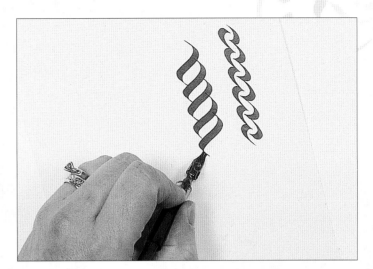

Making Even Strokes *First get the ink flowing by stroking the pen from side to side, making its thinnest line, or by rocking it from side to side. Keep your eye on the speed and direction of the pen as you move it. Apply even pressure across the tip to give the stroke crisp edges on both sides.*

Techniques for Left-Handed Scribes *To achieve the correct pen angle, you can either move the paper to the left and keep your hand below the writing line or rotate the paper 90° and write from top to bottom. (You'll smear the ink if you write with your hand above the writing line.)*

Understanding the Broad Pen

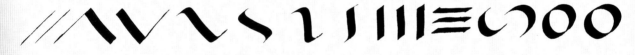

Practice Basic Shapes *Start by making simple marks as shown above, and keep the pen angle constant to create a sense of rhythm. Pull your strokes down or toward you; it is more difficult to push your strokes, and doing so may cause the ink to spray from the nib. Practice joining curved strokes at the thinnest part of the letter, placing your pen into the wet ink of the previous stroke to complete the shape. This is easiest when your pen angle is consistent.*

Draw Decorative Marks *Medieval scribes often used the same pen for lettering as they used to decorate the line endings and margins of their texts. The broad pen can be used like any other drawing tool; practice drawing a variety of shapes to learn more about the pen's unique qualities. For instance, turn the paper to create the row of heart-shaped marks.*

Parts of Letters

This diagram will familiarize you with the terms used throughout the rest of the book. As you can see below, the various stroke curves and extensions of calligraphic lettering all have specific names—refer to this page when learning how to form each letter. Below you'll also see the five basic guidelines (ascender line, descender line, waist line, base line, and cap line), which will help you place your strokes. (See page 17 for more information on ruling guidelines.)

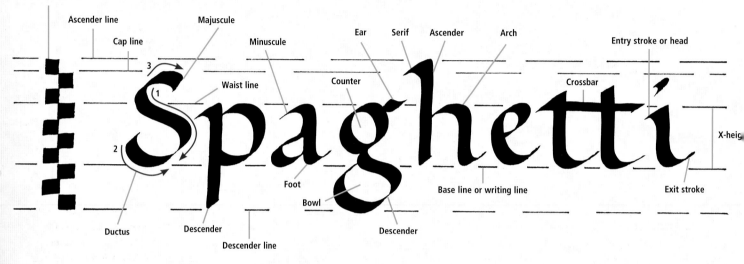

Pen widths (p.w.) · Ascender line · Cap line · Majuscule · Minuscule · Waist line · Ear · Serif · Ascender · Arch · Counter · Entry stroke or head · Crossbar · X-heig... · Ductus · Descender · Descender line · Foot · Bowl · Base line or writing line · Descender · Exit stroke

Forming the Letters

The term *ductus* refers to the direction and sequence of the strokes, which are indicated throughout with red arrows and numbers around the *exemplars* (or letter examples). Broad pen letters are formed with a series of separate strokes, so it's important to follow the recommended ductus while learning. However, with experience, you'll develop your own shortcuts to forming the letters.

Learning Proper Terminology

The terms "uppercase" and "lowercase" come from the era of hand-set type, when individual metal letters were stored in shallow cases; therefore, these terms should not be used in calligraphy. It's better to use the terms "majuscules" (for uppercase letters) and "minuscules" (for lowercase letters). Also avoid using the term "font," which generally refers to computer-generated letters; when referring to different hand-lettered alphabets, use the term "style" or "hand."

Preparing the Paper

No matter what your skill level, you'll usually need guidelines present when doing calligraphy. Without these helpful marks, your writing can lose the rhythm, consistency, and visual alignment that make calligraphy so pleasing to the eye. Follow the steps below to prepare your writing surface with all the necessary guidelines. Remember that you can easily erase light pencil lines when finished, removing any trace of them from your completed work.

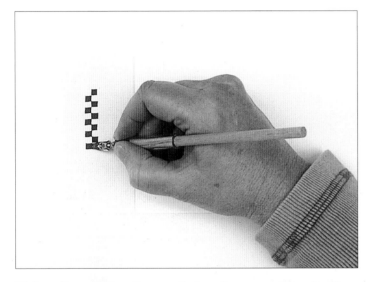

Make a Paper Ruler *On a small piece of paper, mark a series of short pen-width lines, as shown. Turn the pen 90 degrees and begin at the base line, forming a set of stacked squares. Using the pen width as the unit of measurement will keep your letter height in proportion with the line thickness. Each practice alphabet has a designated pen width (p.w.) height, indicating the number of squares needed.*

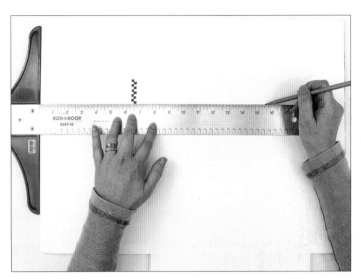

Mark the Guidelines *Place the paper ruler along the edge of your paper and use it to position horizontal guidelines across the paper. A T-square is easier to use than a regular ruler, as you can draw guidelines that are perfectly perpendicular to the vertical edge of your paper. Mark the base line, waist line, ascender line, descender line, and cap line (if working with majuscules). (Refer to page 16 for assistance.)*

Improve Your Lettering with Practice

- Warm up your arm and hand first to gain a sense of control, and remember to take frequent breaks.

- Begin each exercise with the largest nib; this makes it easier to see the contrast between thick and thin strokes created by the broad pen.

- Use smooth, lightweight, translucent paper with a sheet of guidelines placed beneath it for practice.

- Choose the lettering style you like best to practice first. The examples in this book are some of the easiest to learn and require the least pen manipulation or twisting of the pen holder.

- Practice lettering and establishing a rhythm by writing an **o** or **n** between each letter. As soon as you feel comfortable forming letters, start writing whole words.

- Directly trace the letter shapes using a scan or photocopy to practice; this is helpful for beginners and may help you better understand pen angle. On each style page, you'll discover at what percentage the letters have been re-produced in this book. Simply enlarge the letters to 100% on a photocopier for tracing purposes. (For example, if the letters are at 75%, divide 100 by 75. When you get the answer—1.33—convert this to a percentage (133%) and copy your letters at this size.)

- Calligraphy, like dance or yoga, requires practice to achieve grace and flow. Relax and enjoy a peaceful time as you train your hand to shape each letter.

Skeleton

Mastering the skeleton hand gives you the basic skills for learning all the other hands. This hand features the basic underlying structure (or skeleton) of the letterforms. Practicing these letters will train your hand to remain steady while drawing straight and curved lines. I wrote these letters with the drawing nib, which makes a thin stroke, but you can use a fine-line marker or a pencil for practice if you wish. As you re-create the letters of this hand, as well as any other hand, remember that part of the charm and appeal of hand lettering is the imperfections. While I have followed the general rules, the hand-lettered alphabets throughout won't align exactly on the guidelines. (This hand is shown at 85% of its actual size.)

Minuscules

Learning the subtleties of the letter shapes will make the difference between creating plain-looking letters and beautiful ones. Notice that the *o* fills the entire width of a square (equal to 4 grid boxes by 4 grid boxes). Other round letters are about 7/8 the width of that square, and most of the other minuscules (except for the **i**) are 3/4 the width of the square. Proportion and alignment, as well as consistency, all play a part in giving your writing a clean look and producing characters that are easy to read. As you can see, certain letters share common shapes. Practice the different styles using these letter families. By practicing the letters in these groups, you will learn the forms faster.

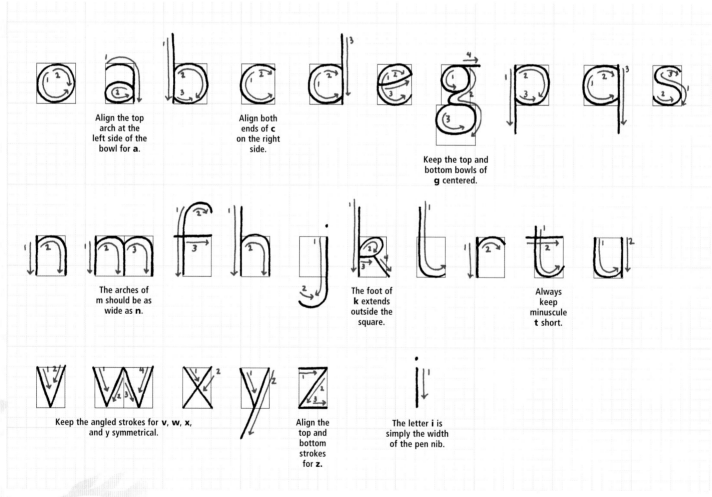

Align the top arch at the left side of the bowl for **a**.

Align both ends of **c** on the right side.

Keep the top and bottom bowls of **g** centered.

The arches of m should be as wide as **n**.

The foot of **k** extends outside the square.

Always keep minuscule **t** short.

Keep the angled strokes for **v**, **w**, **x**, and y symmetrical.

Align the top and bottom strokes for **z**.

The letter **i** is simply the width of the pen nib.

Form these letters using the drawing nib.
This hand is shown at 85% of its actual size.

Majuscules

When drawing majuscules, also called "Romans" by calligraphers, understanding the correct proportions will allow you to consistently form handsome-looking letters. Note that the shape of the **o**, which is the "mother" of every alphabet, will determine the shapes of almost all the other letters.

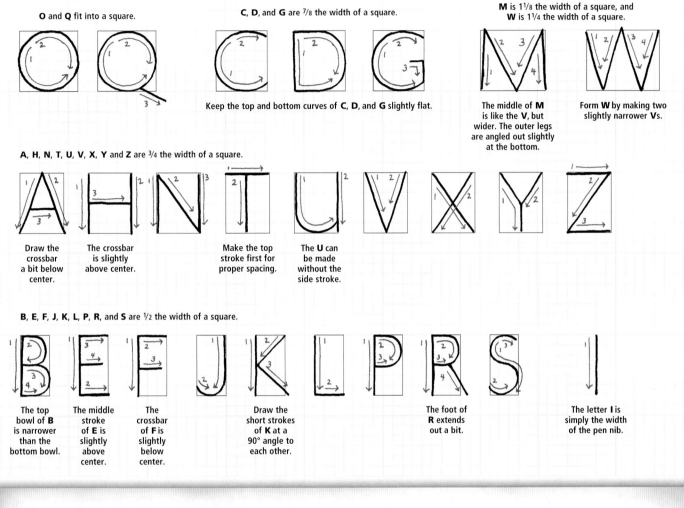

O and **Q** fit into a square.

C, **D**, and **G** are ⅞ the width of a square.

Keep the top and bottom curves of **C**, **D**, and **G** slightly flat.

M is 1⅛ the width of a square, and **W** is 1¼ the width of a square.

The middle of **M** is like the **V**, but wider. The outer legs are angled out slightly at the bottom.

Form **W** by making two slightly narrower **V**s.

A, **H**, **N**, **T**, **U**, **V**, **X**, **Y** and **Z** are ¾ the width of a square.

Draw the crossbar a bit below center.

The crossbar is slightly above center.

Make the top stroke first for proper spacing.

The **U** can be made without the side stroke.

B, **E**, **F**, **J**, **K**, **L**, **P**, **R**, and **S** are ½ the width of a square.

The top bowl of **B** is narrower than the bottom bowl.

The middle stroke of **E** is slightly above center.

The crossbar of **F** is slightly below center.

Draw the short strokes of **K** at a 90° angle to each other.

The foot of **R** extends out a bit.

The letter **I** is simply the width of the pen nib.

Tips

- Remember to experiment! Always test new nibs and papers before starting a final work to see how they respond to the paints or ink.

- You may need to adjust the thickness of the watercolor or gouache according to the angle of your work surface or lay your paper on a less oblique angle to work.

- Keep your work area clean, and check your fingertips when handling finished work. I keep a damp paper towel nearby to wipe off my fingers before touching the paper.

- Do not press down on your pen nib too hard because it will dragon the surface of the paper and may stick in one spot, causing a blot.

- Use a constant speed as you form your letters; this gives your work a rhythm and helps you make the letters more consistent.

Foundational Hand

Begin your practice of broad pen lettering with the Foundational hand—the letter shapes are simple, formed by very basic strokes, and most familiar to your eye. This style was adapted in the early 1900s from a 10th century bookhand by Edward Johnston. It's a great choice for beginners and when legibility is important.

Minuscules

The minuscule letters are easier to master, so begin writing these out before you start on the majuscules. Follow the ductus for each letter, and practice until you are able to form straight up-and-down strokes and smooth, round shapes.

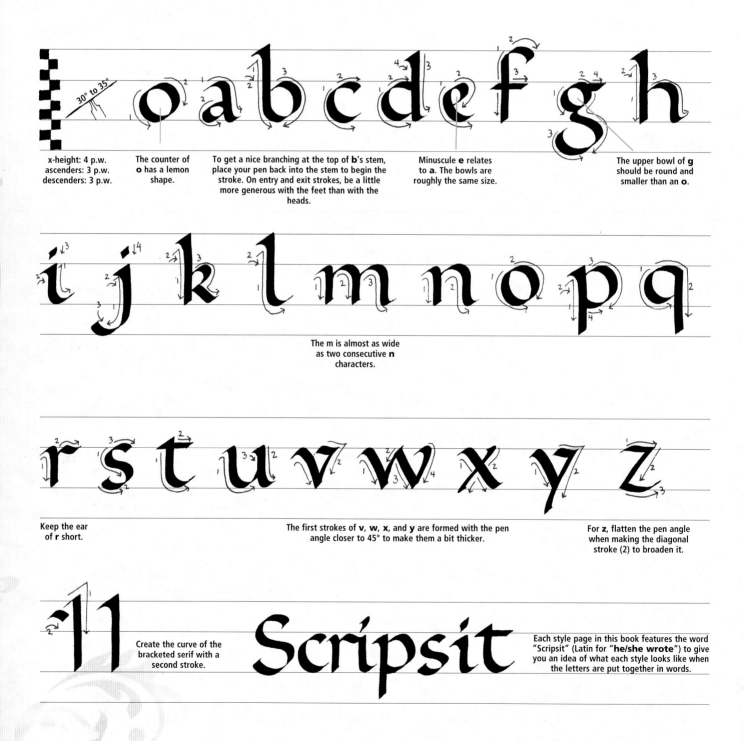

x-height: 4 p.w.
ascenders: 3 p.w.
descenders: 3 p.w.

The counter of **o** has a lemon shape.

To get a nice branching at the top of **b**'s stem, place your pen back into the stem to begin the stroke. On entry and exit strokes, be a little more generous with the feet than with the heads.

Minuscule **e** relates to **a**. The bowls are roughly the same size.

The upper bowl of **g** should be round and smaller than an **o**.

The m is almost as wide as two consecutive **n** characters.

Keep the ear of **r** short.

The first strokes of **v**, **w**, **x**, and **y** are formed with the pen angle closer to 45° to make them a bit thicker.

For **z**, flatten the pen angle when making the diagonal stroke (2) to broaden it.

Create the curve of the bracketed serif with a second stroke.

Scripsit

Each style page in this book features the word "Scripsit" (Latin for "**he/she wrote**") to give you an idea of what each style looks like when the letters are put together in words.

Form these letters using a #1 roundhand nib.
This hand is shown at 85% of its actual size.

Majuscules

As you are familiar with modern letterforms, which are similar to classic Foundational majuscules, it should be easy for you to learn this hand. Practice writing similar letter groupings: round letters, arched or half-round letters, and angled letters. Then write words that use both majuscules and minuscules to develop a sense of spacing and proportion when writing them in combination.

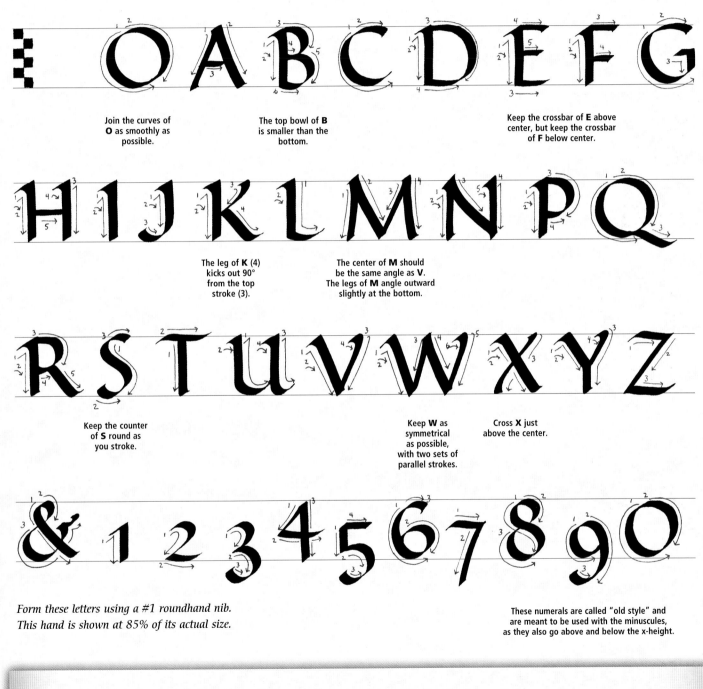

Join the curves of **O** as smoothly as possible.

The top bowl of **B** is smaller than the bottom.

Keep the crossbar of **E** above center, but keep the crossbar of **F** below center.

The leg of **K** (4) kicks out 90° from the top stroke (3).

The center of **M** should be the same angle as **V**. The legs of **M** angle outward slightly at the bottom.

Keep the counter of **S** round as you stroke.

Keep **W** as symmetrical as possible, with two sets of parallel strokes.

Cross **X** just above the center.

Form these letters using a #1 roundhand nib. This hand is shown at 85% of its actual size.

These numerals are called "old style" and are meant to be used with the minuscules, as they also go above and below the x-height.

Keeping Visual Balance

Majuscules should be a little shorter than the minuscule ascenders (in this case, six pen widths). To keep the majuscule and minuscule letters visually balanced, use a 25° to 30° pen angle (slightly flatter than on minuscules), which makes a broader stroke.

Uncial Hand

One of the oldest hands, Uncial (pronounced "un-shul") in many ways is the easiest to learn. This hand can be considered commoncase, as it has elements of both majuscules and minuscules. As you work, keep the letter shapes wide and round. Ascenders and descenders are very short in keeping with this hand's essentially majuscule style.

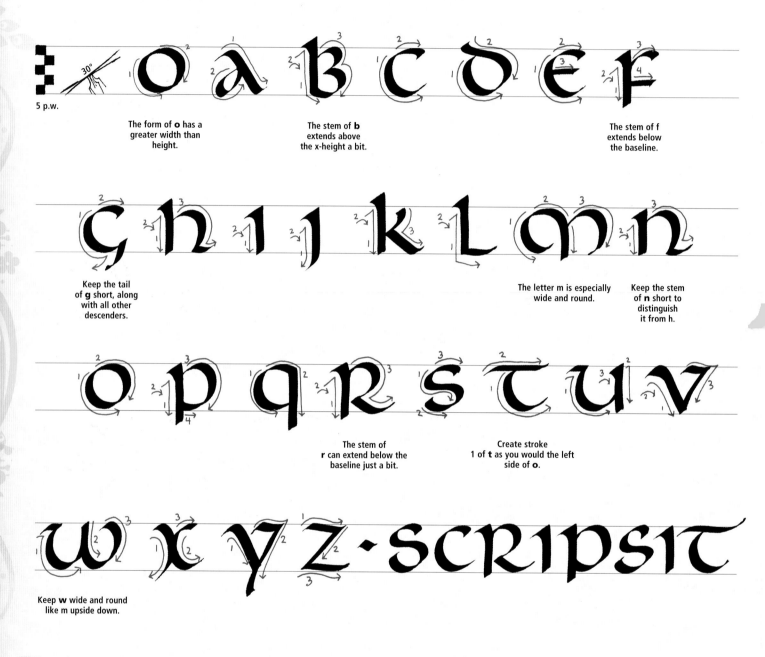

5 p.w.

The form of **o** has a greater width than height.

The stem of **b** extends above the x-height a bit.

The stem of f extends below the baseline.

Keep the tail of **g** short, along with all other descenders.

The letter m is especially wide and round.

Keep the stem of **n** short to distinguish it from h.

The stem of **r** can extend below the baseline just a bit.

Create stroke 1 of **t** as you would the left side of **o**.

Keep **w** wide and round like m upside down.

Form these letters using a #1 roundhand nib.
This hand is shown at 85% of its actual size.

Serifs

Uncial serifs start with a wedge-shaped stroke. Begin with a 30° angle at the start of the stroke and move the nib up and to the right to create a thin line; then pull the nib straight down, toward you, forming the stem stroke of the letter. Fill in the small angle of the wedge with a short curved line.

Majuscules

Italic majuscules feature swashes, which are rounded extensions that flow from the basic form of the letter. Avoid writing an entire word in swashed letters; it will look too busy. When writing whole words and lines, these majuscules can be made without the swashes for a clearer, more readable appearance. Remember, a little goes a long way when adding flourishes to your letters.

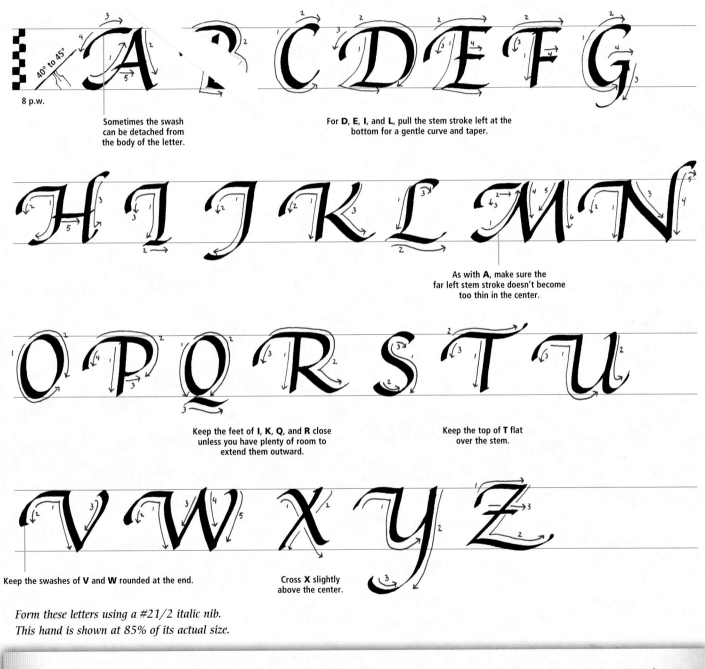

8 p.w.

Sometimes the swash can be detached from the body of the letter.

For **D**, **E**, **I**, and **L**, pull the stem stroke left at the bottom for a gentle curve and taper.

As with **A**, make sure the far left stem stroke doesn't become too thin in the center.

Keep the feet of **I**, **K**, **Q**, and **R** close unless you have plenty of room to extend them outward.

Keep the top of **T** flat over the stem.

Keep the swashes of **V** and **W** rounded at the end.

Cross **X** slightly above the center.

Form these letters using a #21/2 italic nib.
This hand is shown at 85% of its actual size.

Drawing Swashes

The swashes on italic majuscules are very generous in width, doubling the width of the entire letter in many instances. Use these large swashes to add emphasis to words or to begin a page.

Planning Your Designs

When first learning calligraphy, concentrate on how each individual letter is made. The spacing of the letters in a word and the arrangement of the lines of words on a page are an important part of this art form. The composition (the arrangement of all the elements in a completed work) is as important as the individual details.

Focusing on Spacing

When combining letters to form words, the objective is to produce an even visual texture. Remember that the space between the letters is as important as the space inside the letters; the spaces should appear consistent throughout the word and the page. You'll find that spacing is not as simple as it sounds—you shouldn't use the same unit of measurement between each letter, as the edges of adjacent letters create unique space shapes that require different treatment. Instead, place letters based on the volume of space on either side. For minuscules, the vertical strokes should appear evenly spaced. Majuscules, however, require more room and are more difficult to space visually. You can train your eyes to see consistent spacing; try looking at groups of three letters and gauge the space by the shape and volume you see on both sides of the middle letter.

Spacing the Minuscules

You can check your progress by using a tracing paper overlay. Write each of the letters with an **n** between them as an effective spacer. Draw vertical lines along the stems and vertical strokes of your letters; for **s**, draw the line down the middle of the letter. If you've produced consistent spacing, these lines will be roughly the same distance apart (see the first line of letters below).

Spacing the Majuscules

Using the same unit of measurement between letters results in an awkward flow, as shown in "Tabula Rasa" (second line below). Instead, vary the distance so that there is roughly the same volume of space between the letters, as shown in "Tarot" (third line below). Some guidelines for spacing are given in the bottom line below.

anbncndnenfngnhninjnknl

TIABIULIA RIAISIA

TAROT

| Two straight stems will be close together. | Position two round letters the closest of all. | This is a tricky combination: Keep the space close at the bottom. | Don't put two diagonals too close. |

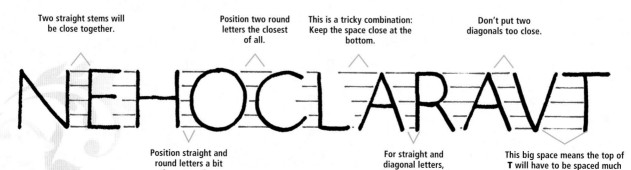

| Position straight and round letters a bit closer together. | For straight and diagonal letters, close up the space. | This big space means the top of **T** will have to be spaced much closer to **V**. |

Spacing Words

To get a feel for the proper spacing between words, write practice sentences with **n** in between each word. The **n** provides a natural-looking space and minimizes variation. Keep spaces to a minimum to prevent rivers (vertical visual gaps down the page created by word spaces).

terra*n*incognito

Ligatures

Ligatures, the joining of two letters, occur naturally in combinations where extensions or serifs meet at the waist line. However, not all letters in ligatures actually touch, as this might create the look of another letter. Look at the **rn** combination. In the ligature, the **n** simply lacks the serif; if the letters touched, they would resemble an **m** too closely.

fi rn rt rv tt gn
fi rn rt rv tt gn

Preparing Layouts

Composition is the purposeful organization of elements. Plan out the arrangement of your text before you start writing so you can include all of the material while maintaining a sense of balance. Alignment plays a huge role in the overall layout of a page. Text may be aligned left, aligned right, centered, justified (aligned on both sides of the text block), or asymmetrically placed. To make the text easy on the eyes, keep the margins generous, with the bottom margin larger than the top and sides. The thumbnails below show vertical arrangements (the top row shows effective layouts; the bottom row shows problematic layouts). Remember that layouts may be horizontal as well.

Effective Layouts

Classic centered layout	Centered with lines arranged asymmetrically	Justified text	Aligned left	Aligned left with large versal

Problematic Layouts

The diagonal lines formed by the calligraphy in this layout lead the eye off the page on the right.	This wandering layout is fragmented and lacks focus.	When margins are equal on all sides, the text appears bottom heavy to the viewer's eye.	Narrow margins at the top and sides and large spaces within the text create a choppy layout.	This text has a weak center; remember that the area around the text also is a shape.

CHAPTER 2
Calligraphy with
Arthur Newhall
& Eugene Metcalf

In this chapter, Eugene Metcalf and Arthur Newhall provide instruction on an array of additional hands to try. From stately Roman and Chancery styles to an elegant Batarde alphabet, you'll find these hands to be staples for any calligrapher's repertoire. You'll also discover styles of numerals to copy, as well as flourishes, borders, and other design tips.

Sans Serif

Sans Serif is a basic, simple letter style that is quite easy to execute with a broad-tipped pen (such as the #1 roundhand). It is a thick-and-thin Roman alphabet without serifs.

The vertical down stroke and horizontal strokes are made with a firm wrist action; the curved strokes are guided with the fingers. The pen angle is 35° with no rotation of the pen.

Below, the various elements of Sans Serif have been broken down into separate practice strokes. Practice these basic strokes until you feel comfortable with your pen. The angle of the pen creates the thick-and-thin characteristic of the letterforms—little pressure is needed.

Practice Strokes

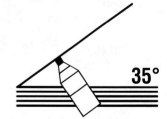

Majuscules

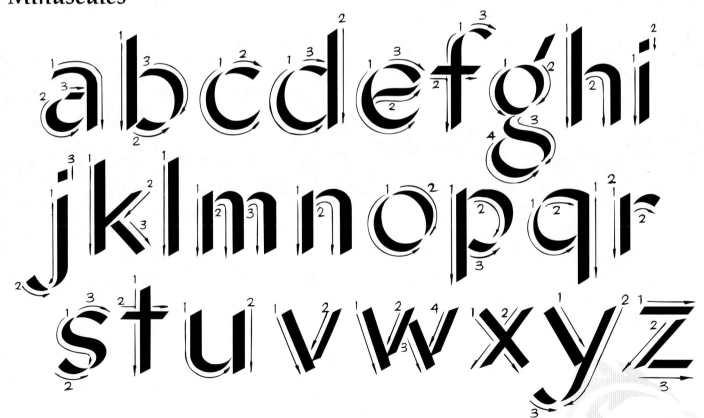

ABCDEFGHI
JKLMNOPQ
RSTUVWXYZ

Minuscules

abcdefghi
jklmnopqr
stuvwxyz

Majuscules

ABCDEFGHI
JKLMNOPQ
RSTUVWXYZ

Minuscules

abcdefghi
jklmnopqr
stuvwxyz

36

Roman

Roman letters are the foundation for many of the alphabets we use today. Roman stone cutters and scribes developed the classic form. There are many variations of the Roman alphabet, but the basics remain unchanged.

The Roman majuscules are made with a pen angle of 30°. The serifs are executed by first making an almost horizontal stroke across the bottom of the letter. Then the pen is arced to the right and then to the left to finish the serif. A short vertical stroke with the pen edge is made and then filled in to finish letters **C, E, F, G, L, T,** and **S**.

The elements of the Roman alphabet have been broken down into separate practice strokes. First practice the strokes and serifs, and then practice the actual letterforms.

Practice Strokes

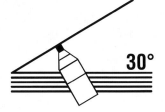

30°

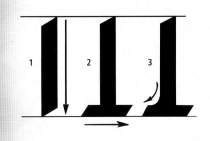

Serif Detail

1. Pull the stem stroke to the guideline.
2. Make a short horizontal stroke.
3. Place the pen tip on the stem and swing an arc to the left.

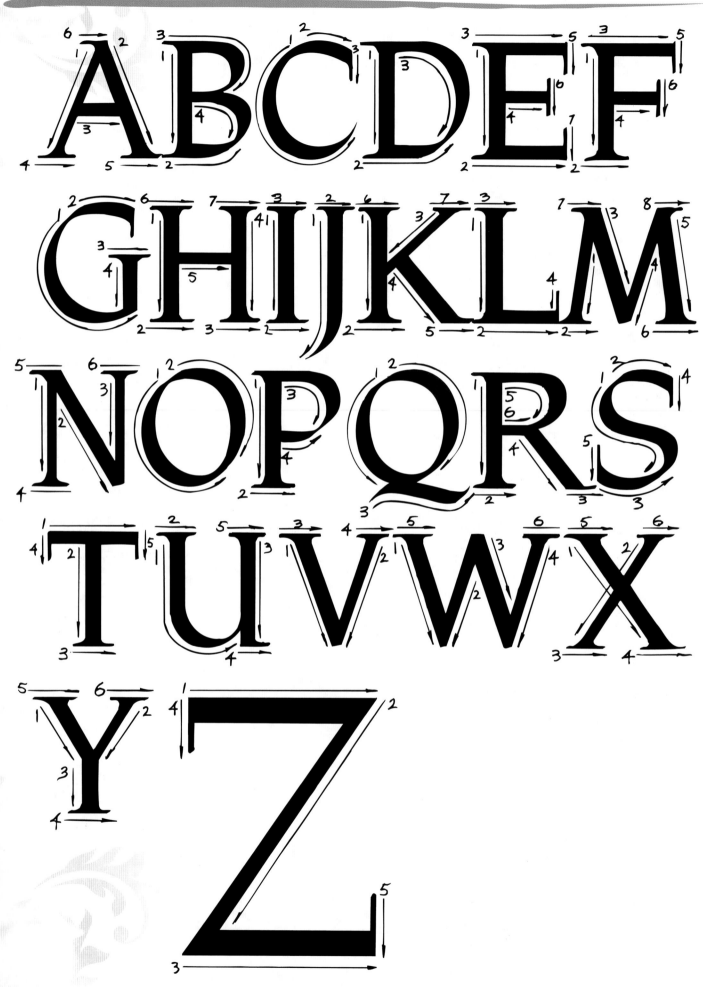

ABCDEF
GHIJKLM
NOPQRS
TUVWX
Y Z ROMAN

Chancery Cursive

Chancery Cursive is a favorite with calligraphers because of its beauty, function, and speed of execution. Chancery Cursive is an italic letter that is ideal for manuscripts, poetry, diplomas, awards, testimonials, or any situation requiring a mass of copy. The beautiful form blends well with most calligraphic alphabets. The majuscules can provide distinctive flourishing at the beginning of a piece.

The Chancery Cursive letter lends itself beautifully to the broad-tipped pen. The letter shapes are tall rather than fat. The pen angle is 45° and the letter stroke is 10° to 15° off the vertical. The pen does most of the work and little pressure is needed.

Below are the broken-down elements used to create each letter of the Chancery alphabet. Practice these strokes, and then follow the sequences to execute the actual letterforms.

Practice Strokes

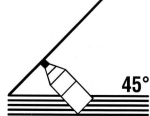

Majuscules

A B C D E F G
H I J K L M
N O P Q R S T
U V W X Y Z

Minuscules

a b c d e f g h i
j k l m n o p q r
s t u v w x y z

Batarde

Batarde is a beautiful angular alphabet that was developed in France during the 15th century. Batarde is a natural for the broad-tipped pen. It is a very angular form and the strokes are made with little difficulty. It is best to use one of the broad-tipped pens to achieve the sharp ribbon effect.

The pen is held at a 30° angle. The uppercase letters are quite wide and contrast well with the tightly packed minuscules. Batarde combines beautifully with Chancery Cursive and other italics.

Again, use the practice strokes to master the basic elements of the Batarde alphabet. Then use the stroke sequence to complete the letters of the alphabet.

Majuscules

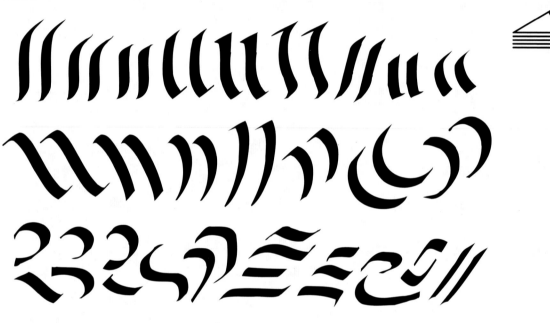

Minuscules

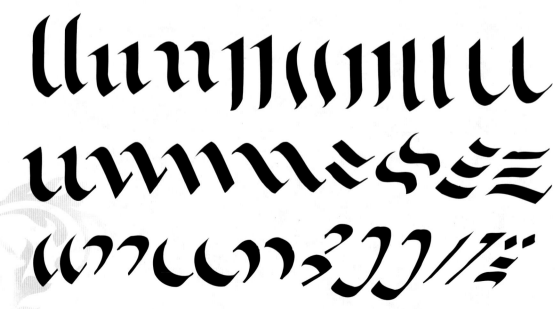

Majuscules

ABCDE
FGHIJK
LMNOP
QRSTU
VWXYZ

Minuscules

abcdefghij
klmnopqrs
tuvwxyz

43

Numerals

Here are several styles of numerals that should be appropriate with most letter styles. It is not necessary to use the same form as the rest of your message. A distinctive numerical style can add interest to your piece.

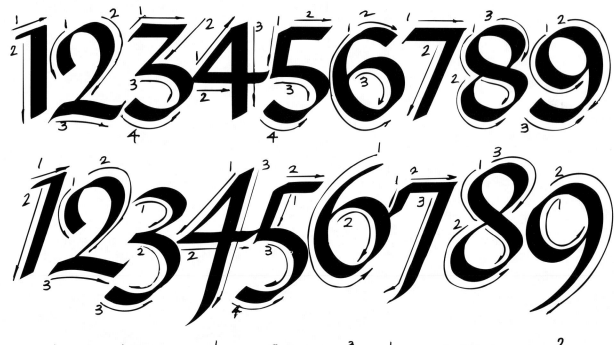

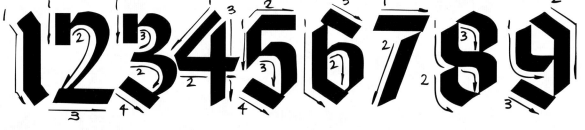

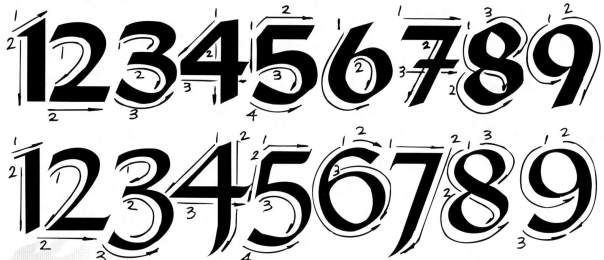

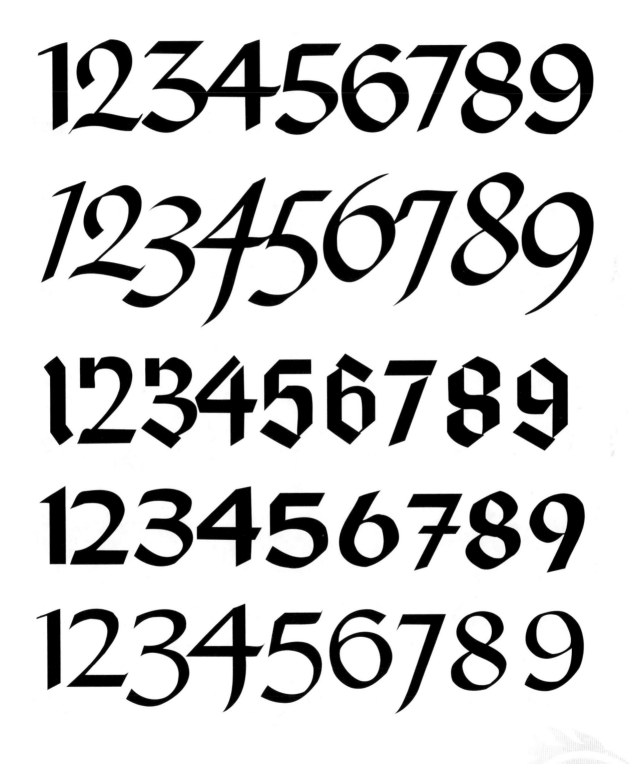

Flourishes & Borders

Once you become comfortable with creating the letters and alphabets in this book, you can begin to embellish them with beautiful flourishes and swashes, and surround them with decorative borders—the possibilities are endless!

Flourishes and Swashes

The stylish addition of flourishes and swashes serves a double purpose by enhancing the space and adding unexpected interest. But it is important that these strokes be added with discipline and planning. The bold ribbon swash is done with the same broad pen as the lettering. A smaller pen is used for the more delicate swashes, and a fine-point pen is used for the hairline flourishes.

Borders

Borders can be made in a variety of styles, from very simple to ornate. They are often used to set a theme or create a mood. They can be used to enhance a name, title, or logo. In print they can draw attention to a specific space. A border might completely surround the lettering or be only on the top, bottom, or sides. They must retain the character of the subject and the lettering used.

Design

Now let's mix calligraphy with creativity. First remember that good lettering design emphasizes important words, creates interest, and expresses the proper mood and feeling. This is achieved through contrasts of size, weight, form, and direction. Study the following examples to see how you can use these contrasts to create unique designs that complement the nature of the text.

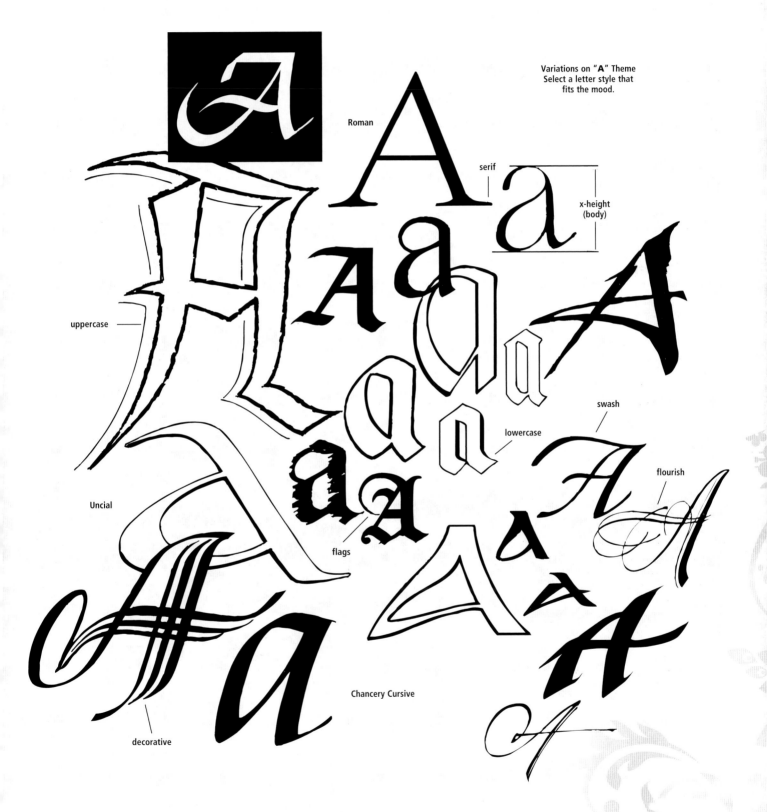

Variations on "A" Theme
Select a letter style that fits the mood.

Roman

serif

x-height (body)

uppercase

lowercase

swash

flourish

Uncial

flags

decorative

Chancery Cursive

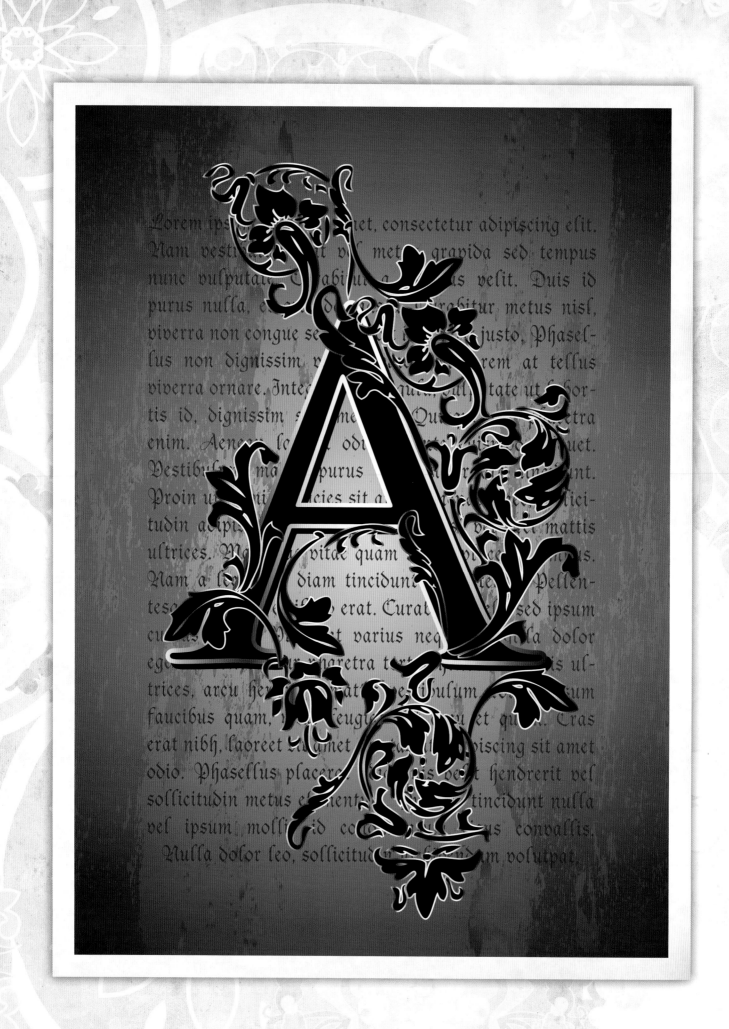

CHAPTER 3
Illumination with
Cari Ferraro

Now that you've tried your hand at calligraphy, expand your skill set to include the art of illumination. Chapter 3 introduces you to this decorative art form, teaching you how to mix gouache paints, load your pen, and create colorfully embellished words of art.

Color Theory

While practicing the basic letterforms, a tube of black watercolor paint (or a bottle of black ink) is all you need. But once you begin making words on a page to display and share, you may want to incorporate color into your lettering. Of all the media you could use, gouache provides the most brilliant color. Gouache is a painting medium similar to watercolor, but it has more opaque filler in it to give a more solid coverage. To complete the illumination projects in this book, you'll need cobalt blue, leaf green, lemon yellow, brilliant red, white, and gold gouache paint. Read on for information about mixing color and how to prepare your pen for writing with gouache.

Mixing Color

Learning the basics of color theory allows you to create a spectrum of colors from just a few tubes of paint. All you really need are the primary colors—red, yellow, and blue. These colors can't be created by combining any other colors, but you can mix them together to create virtually any other color. For example, mixing two primary colors together creates a *secondary* color (green, purple, or orange), and combining all three primaries results in a neutral brown or gray. The color wheel below illustrates the relationships of primary and secondary colors. The wheel also suggests two versions of each primary, giving you an ideal starting palette for mixing a range colors.

Color Wheel

Make "tints" by adding white to colors, as shown on the outer edge of the color wheel. For darker "shades," add black. To gray a color, simply add a bit of its complement (the color directly across the color wheel). You can achieve neutral colors by mixing nearly equal amounts of complementary colors, as shown in the center. For a neutral gray, use more blue; for brown, more red; and for ochre, more yellow.

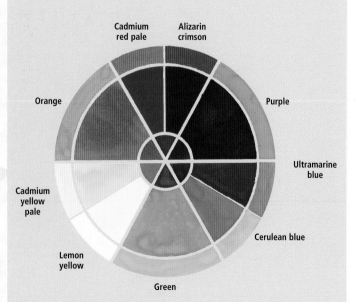

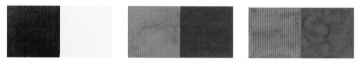

Dynamic Complementary Colors *Complementary colors appear opposite each other on the color wheel, and they appear brighter when placed next to each other, as shown below. Complementary colors often are used to create dramatic contrasts in artwork.*

Harmonious Analogous Colors *Analogous colors appear next to one other on the color wheel. Because their hues (or family of colors) blend smoothly together, they impart a harmonious feeling when used together in a work of art. Below is a range of analogous colors from lemon yellow through cerulean blue.*

Rich Neutral Colors *Make neutral grays and browns by mixing the three primary colors together, varying the proportions to alter the final result.*

Grayed Darker Colors *Many artists prefer not to use black to darken colors, but to add a touch of a color's complement to the original paint color to create a rich-looking neutral shade. This example shows greens that have been neutralized (or grayed) with a touch of red.*

Writing with Gouache

Lettering with gouache allows you to paint with words from your pen. While this technique requires a bit of preparation to achieve the right consistency to flow from the pen, the effort is worth the reward of seeing your calligraphy come to life in brilliant color.

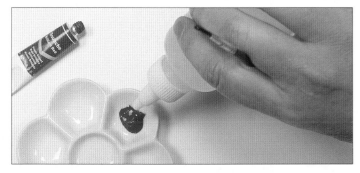

Step 1 *Squeeze out a pea-sized amount of gouache on the palette, which is enough paint for about half a page of writing. Add distilled water one drop at a time and mix with the large brush until it is the consistency of cream. (Distilled water doesn't contain minerals that can affect the pigment.)*

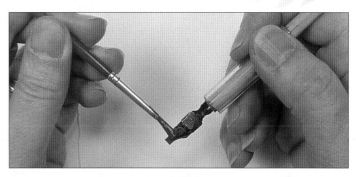

Step 2 *Now load the large brush with the mix and drag the brush across the side of the nib (over the gap between the nib and reservoir). If you decide not to use a reservoir, simply drag the brush across the bottom of the nib.*

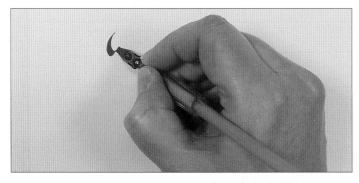

Step 3 *Practice making a few strokes and forming a few letters. Adjust the thickness of the gouache as needed to get it to flow evenly from the nib. (Should you choose to work with ink, note that the gouache will have a thicker consistency.)*

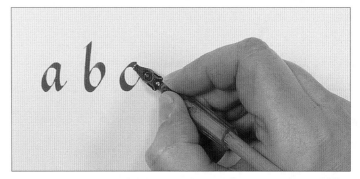

Step 4 *Write a few more letters, and you'll begin to understand how to control the flow of the paint with consistent speed and proper pressure.*

Tips

- Use distilled water to thin gouache for lettering.
- The bigger the pen nib, the thinner the paint needs to be. Small nibs require thicker paint or ink.
- A new tube of gouache has a few drops of glycerin at the top to keep the paint moist. Squeeze out the glycerin onto a paper towel and discard it before using the paint.
- Mixed gouache may thicken on the palette as you work; thin it as needed with drops of distilled water.
- Clean the nib often by dipping only the tip in water and wiping it dry. Be sure all moisture is wiped off the nib before putting your tools away.
- When painting highlights and other details, dip just the tip of the brush into the paint and wipe off any excess on the edge of the palette cup.

- As you work, periodically stir the paint to maintain an even distribution of the water in the paint.
- Work on a flat surface when lettering with gouache to keep the paint from pooling at the bottoms of the letters. Dried gouache can be reconstituted with water, but some colors may not reconstitute easily.
- Color is a great way to express emotion in calligraphy. Go slowly as you learn the properties of gouache, but have fun experimenting with different colors! Use basic color sense: red is exciting, yellow is happy, blue is calming, and so on.

Designing a Quote

A short quotation makes a great subject for learning to place words in a layout. Choose a saying that will comfortably break into two or three lines, but not one that is so wordy that you won't want to practice writing it a few times.

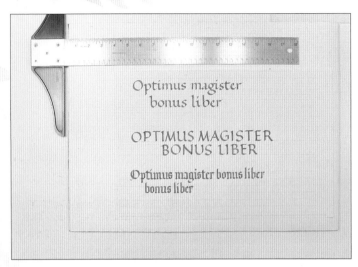

Step 1 *Practice writing your quote in different hands; then choose the most suitable hand for the message. This Latin quote roughly translates to "The best teacher is a good book," so I chose the easy-to-read Foundational hand. Use a #1 nib to write your quote on layout or grid paper. At this stage, don't worry about the arrangement of the words.*

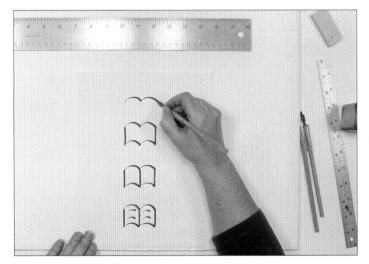

Step 2 *Practice drawing an image that's appropriate for your quote. I drew a small book, using the same nib held at the angle that was used for the lettering. Experiment with suggesting text lines and varying line weight. Keep the sides of the book vertical to echo the straight lines of the letters.*

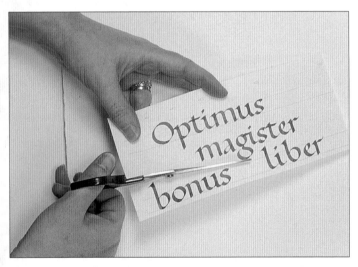

Step 3 *Now cut out each word and your drawing to make separate, movable pieces. Place the pieces in different arrangements on a large piece of blank white paper. Decide which layout is most pleasing to your eye. (See page 31 for layouts to try.)*

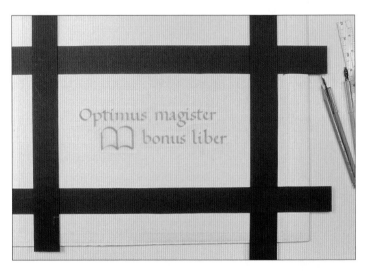

Step 4 *After you choose an arrangement, view your layout within borders. Cover the layout with tracing paper; then use two L-shaped pieces of black mat board or four strips of black paper to crop your layout and determine the margins. Once you're satisfied, you can create the final artwork.*

Adding a Decorative Element

To add visual interest, use a broad pen to make a simple drawing that complements the idea and the letter style of your quote. Using the same pen width to create the drawing and the letters will make the drawing flow visually with the text. At the right, the open book illustrates the word "liber," which means "book." Using red gouache draws attention to the drawing.

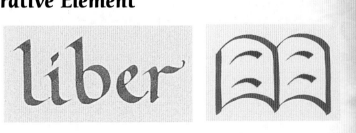

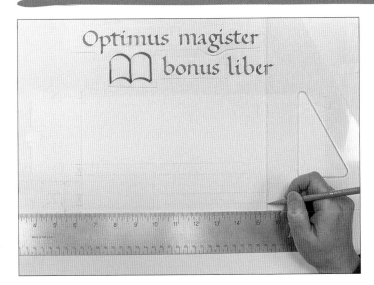

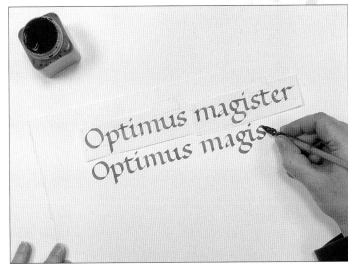

Step 5 *First, draw the baselines on art paper with a pencil; place a light x at the beginning of each baseline to distinguish it. Make a paper ruler for the hand you're using, and lightly draw the rest of the horizontal lines on the paper. Transfer the vertical guidelines by placing the layout directly above the art paper. Use an artist's triangle to help position your marks.*

Step 6 *Warm up your hand by practicing on another sheet of paper before starting your final work. Refer to the cut-out words placed above your work when producing the final writing. Soon you'll be able to letter it without using the layout—and eventually without the ruled guidelines.*

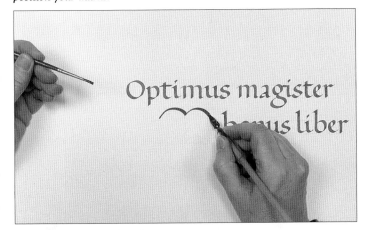

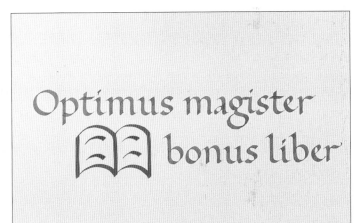

Step 7 *After completing the words, use red gouache to draw the book. When the ink and gouache are completely dry, carefully erase the pencil lines. Cut a corner off your eraser with a craft knife, so you can erase in small areas. Be careful not to scrub the red gouache when erasing.*

Step 8 *Now you have an expressive, but simple, illustrated quote. Be sure to save some of your early projects—it will be interesting to look back at them in a few months to see how far you have progressed!*

TIP

You may find it easier to work on your final piece when you've ruled two or three sheets of art paper, as in Step 5. This reduces "performance anxiety" and lets you move on quickly to another paper if you make a wobbly mark or don't like the quality of your strokes.

Changing the Layout

After you write your practice words, cut them out. Try different layouts with them. You may opt for a classic centered layout, like the one shown here, rather than the horizontal layout above. To find the center of each word, draw a vertical line on the center of the background paper; then fold each word in half to find its center. Align each word's center to the line on the paper, and attach the words to the paper with low-tack or artist's tape to use as a guide.

Illuminating Letters

The word "illumination" comes from the Latin word *illuminaire*, which means "to light up or enlighten." In calligraphy and book art, it refers to decorating a page with bright colors and shimmery gold. Decorated majuscules and intricate borders lit up the pages of ancient books and offered an exciting way to provide colorful focal points among black lettering. You can achieve the same look.

Step 1 *Rule two parallel lines one to two inches apart on art paper. As a shortcut, you can draw lines along both edges of a ruler.*

Lettering in the Ancient Runic Style

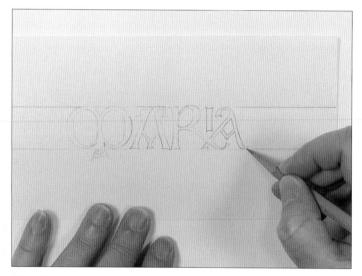

Step 2 *Use a pencil to lightly draw a word on the art paper between the two parallel lines. In this case, the word is "Maria."*

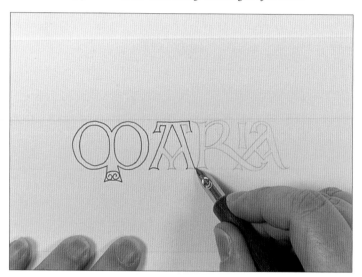

Step 3 *Use the drawing nib; a narrow, flat nib; or the small brush to outline the letters with black paint. Let the ink dry and carefully erase the pencil outlines.*

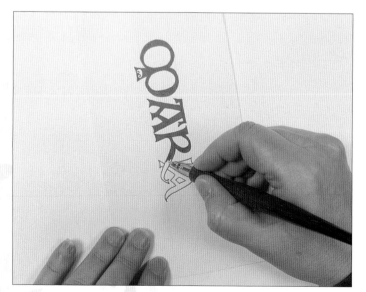

Step 4 *At this point, use a thick nib or the small brush to fill in the letters with black paint, carefully moving your tool within the outlines.*

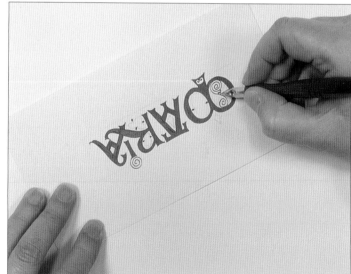

Step 5 *Draw designs in the counter shapes and add some decorative spirals. The spiral used in the left counter of the M is a simple S shape with a fuller bottom. Draw a border around all the letters, and ink in the spirals.*

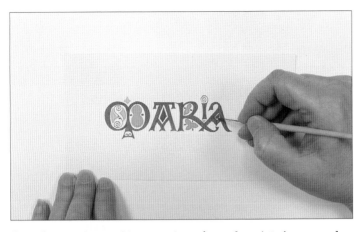

Step 6 *Prepare several intense mixes of gouache paint. As you work across the word and fill in the counters with shapes, alternate your paint colors.*

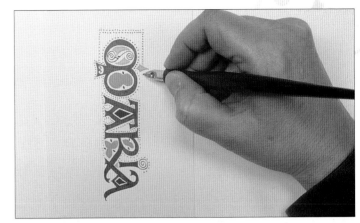

Step 7 *Use red gouache in the drawing nib to apply rows of red dots around the letters and the borders of the panel. Try to space your dots evenly, but don't worry if your dots don't exactly line up—this imperfection will give your work a natural, organic quality.*

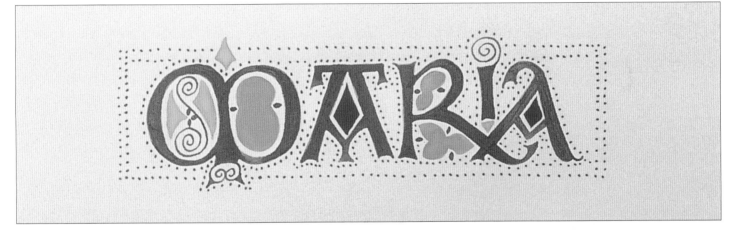

Step 8 *The completed project is based on ancient forms but has an eclectic look.*

Tips for Illumination

- Some of the earliest illumination was done by the Irish scribes who produced the Books of Kells and the Lindisfarne Gospels. Neither of these books used gold leaf, but instead used bright colors and rows of red dots to visually lift the letters off the page.
- A bright red accent adds a bit of magic to the page. Medieval illumination artists understood that red attracts the eye, so they often used red when decorating versals.
- The sequence in which you work is important. The traditional order is to do the lettering first, then the gilding, and the color painting last. Gold paint may be applied at the same time as the colors, but always do the lettering first. It's easier to hide mistakes in the borders than within the calligraphy.

- Gather visual reference materials from books or the Internet when planning a project. Experiment with different color combinations and decorative elements.
- Don't abandon your lettering practice once you start illuminating. Good calligraphy skills are essential to quality illumination.
- When working with color, keep your brushes very clean. Keep two water jars for consecutive rinsing. If possible, use separate brushes for different colors—particularly light and dark shades.

Creating an Illuminated Gothic Letter

Book illumination rose to the height of intricacy and beauty during the medieval era. Artists often applied gold leaf to letters or to the backgrounds of versals and illustrations, which would catch the light as the page turned. Today gold paint offers a similar effect that artists can use to create historically inspired Gothic letters, such as the **V** below. The Latin word *viriditas* means "the greening power of life," so I infused the border with plenty of green vines. I created this image using a tracing method to transfer the design, which I explain on the next page.

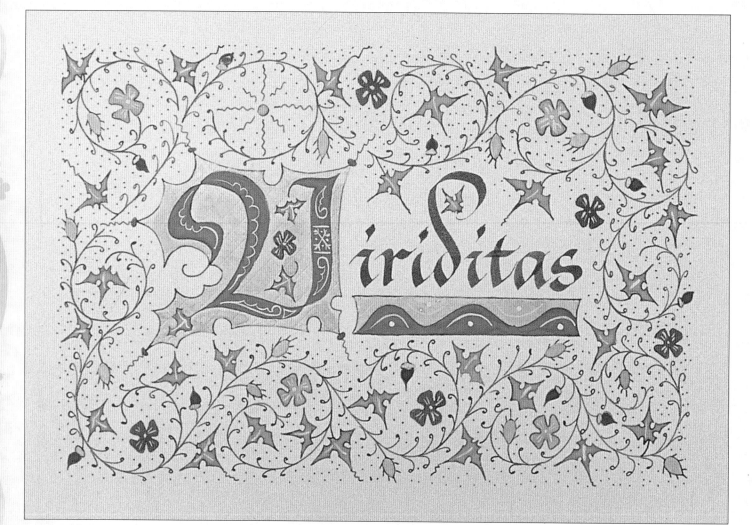

Transferring the Design

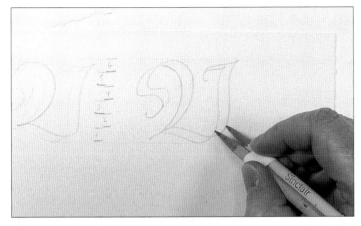

Step 1 *Tape two pencils together to create a tool for drawing large, unfilled letters. Make a pen-width scale, as you have with a nib, by using the width of the pencil tips. To achieve a desired width, adjust the angle of the pencil points to an imaginary horizontal base line. Then outline your Gothic letter.*

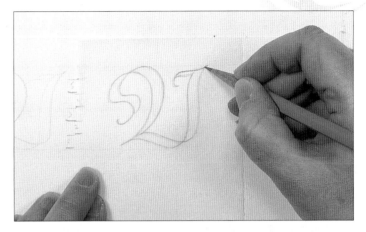

Step 2 *Tape tracing paper over the original letter, and trace it with an HB pencil, keeping the lines fluid. Draw the curves toward your drawing hand for a more natural line. Then turn over the traced letter and apply a thin layer of graphite over the back of the letter with a soft B pencil.*

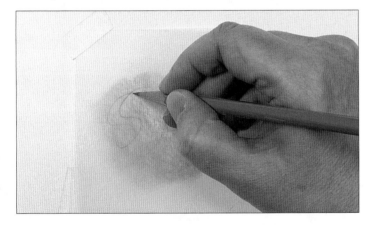

Step 3 *Now position the traced letter on the final art paper, graphite side down. Align the letter within the border of your paper using a triangle and a T-square. Then retrace the letter using an H pencil. The graphite on the back of the tracing paper will transfer the letter onto your paper.*

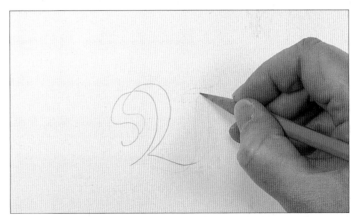

Step 4 *Remove the sheet of tracing paper to reveal the letter on your art paper. Then use a pencil to touch up the lines, as they may not transfer perfectly. Clean up any smudges with an eraser. Once you're happy with your final letter, you can add the decorative background around it.*

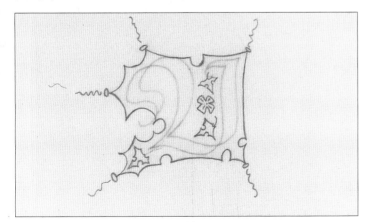

Step 5 *On a tracing paper overlay, draw the decorative shape around the **V**. Keep the lines close to the letter, creating a roughly square shape with medieval spikes. Add a few ivy leaves and a flower to fill awkward spaces. On the left side, away from where the letters will be, let the spikes flare out.*

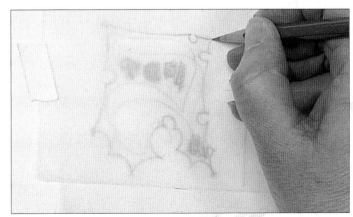

Step 6 *Turn the tracing paper over and use the side of a soft B pencil to apply a layer of graphite over the leaves, flower, and border. Follow the procedures you used in steps 2, 3, and 4 to transfer this background to your art paper.*

Creating the Illuminated Letter

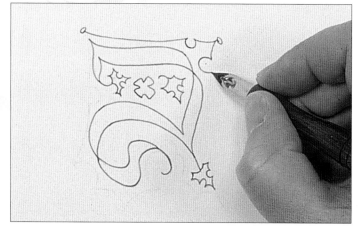

Step 7 *Use the drawing nib and thinned black paint to outline the letter, leaves, and flower. Keep the line weights consistent throughout the drawing.*

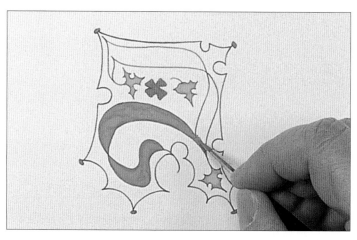

Step 8 *Prepare dark green, light green, pink, golden yellow, blue, and gold in your palette. Use the smallest brush to carefully paint the letter, leaves, and flower. For tight corners, pull the brush toward the corner, lifting the bristles off the paper as you approach the corner.*

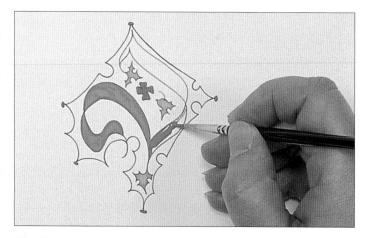

Step 9 *To get opaque coverage, first paint the area with thinned gouache; then flood it with thicker paint. Complete an entire area before moving to the next part of the letter. Gouache creates hard edges when it dries, so painting one area at a time keeps your strokes smooth.*

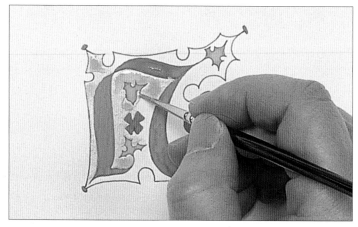

Step 10 *Use gold paint to fill in the background. The gold needs to be fairly thick to cover the area well, but thin enough so you can tease it into corners with the tip of the brush. Add some squiggles at the corners with black paint.*

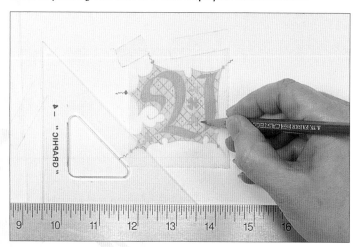

Step 11 *After the paint dries, place two layers of paper towel beneath your art paper. Place tracing paper over the letter, and use a straightedge and a sharp pencil to impress criss-crossing diagonal lines across the gold for a debossed look.*

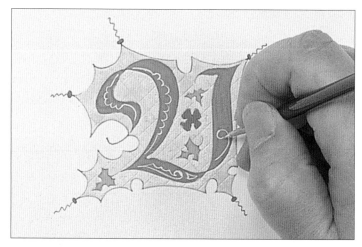

Step 12 *Use the small brush to paint white highlights on the letter, leaves, and flower. The white paint needs to be thicker than the mixture used for filling (such as the green), but thin enough to flow easily from the brush.*

Painting the Medieval Border

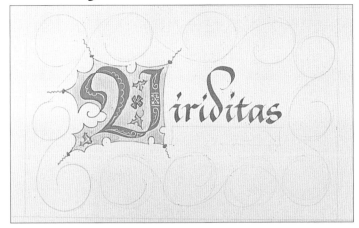

Step 13 *Use black paint to letter the rest of the word in a Batarde hand. Draw a border around the letters, and add the design under the word. Draw circles within the border. Add stems following the circles, alternating the direction of the vine around each circle.*

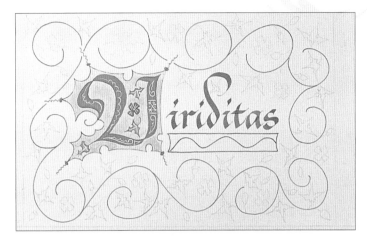

Step 14 *Use the drawing nib to ink the outline of the vine. Allow this to dry and erase any pencil lines. Outline the small design beneath the bulk of the word, and add a wavy line across its center. Then draw some ivy and other elements with a pencil.*

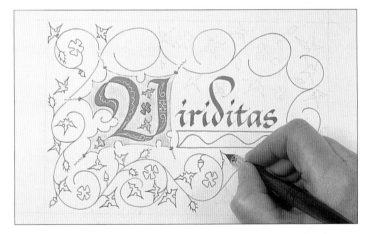

Step 15 *Now go over the leaves, stems, and flowers using the drawing nib filled with thin black paint. Keep your lines fine and consistent, so there aren't any gaps, wide lines, or dark spots to distract the eye.*

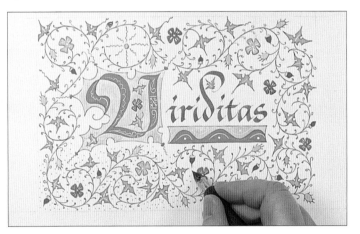

Step 16 *Use the small brush to paint the leaves and flowers. Fill in the small border using the same colors as the V. Use the drawing nib to add buds on the stem lines in the outer border, keeping them within the rectangular shape.*

Creating a Decorative Border

- Remember to draw the curves of the vines toward your hand for a more natural line. This motion applies to calligraphy as well; in most cases, you will pull each stroke down and to the right, turning the paper as needed.
- Keep your gouache washes fresh on your palette by stirring them frequently with a clean, moist paintbrush. Then you can spontaneously switch between colors while painting the flowers and leaves.
- To add texture and interest to your border, contrast the thin, curving lines with small dots using your drawing nib. Called "stippling," this technique can also be performed using the tip of a round paintbrush.

Modernizing Ancient Styles

Today's scribes still use decorated letters to call attention to a special word or name. Although the letter **R** below is based on classic, calligraphic design principles, I've used a looser style for the painted background, resulting in an airy, light-hearted look that has moved away from the traditional Gothic style.

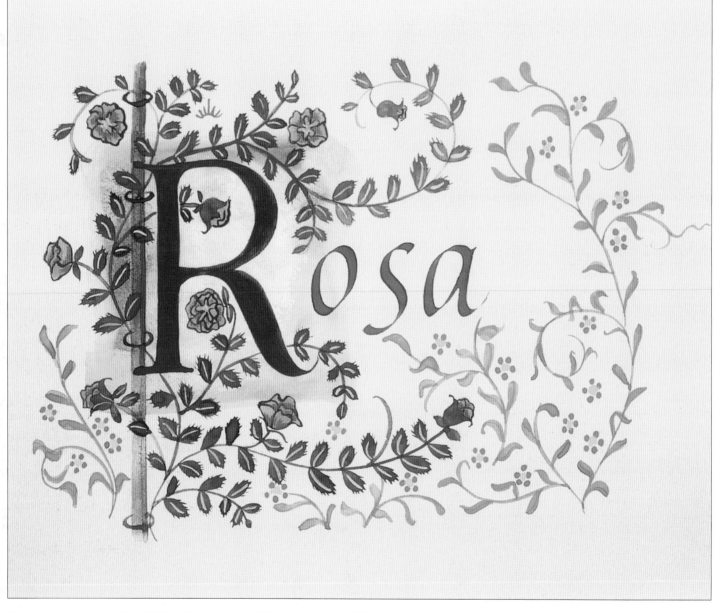

This border was inspired by William Morris' Book of Verse, written in 1870 at the start of the Arts and Crafts Movement in England.

Painting the Background

Step 1 *Lightly draw an outline for the background square. Prepare thinned yellow, red, and green gouache paint for the washes. Use a large brush dipped in clean water to loosely apply a square of water within the border.*

Step 2 *Load the brush with the lightest color. Touch the brush to the wet paper to apply a little color at a time. Keep the yellow at the center, as shown; then you can frame the yellow by dabbing and dragging the red around it.*

Step 3 *After adding the red, drop green into the edges. This will define the brush shapes you used to paint the square. If you like, "float" a brush full of thinned gold gouache into the wet paint. The gold gives a subtle shine to the background when it dries.*

Step 4 *You may need to remove some of the extra water as you work. Take a piece of paper towel and roll it into a thin pencil shape. Touch it to the most puddled water to draw up the excess water, being careful not to absorb too much pigment.*

Wet-into-Wet Painting

- To paint wet into wet, dampen the paper with a wet brush and then apply diluted color to the damp paper, as shown in steps 1, 2, and 3. The result is flowing colors that blend into one another, creating new colors where they meet.
- Tape the edges of your paper onto your work surface to prevent the paper from buckling as it dries.
- The heavier the paper, the less it will buckle. Always test your paper before starting.
- Experiment with color combinations on a piece of scrap paper first.
- This wet technique may take a couple of hours to thoroughly dry; don't move your paper while it's still wet, or the pooled color may run.
- The results of this technique may not be what you are expecting, but be open to surprises. The coloring that emerges when the background dries may help you decide which letter you will want to paint onto it.

Adding the Versal

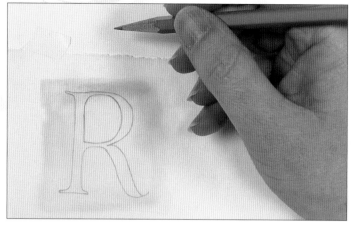

Step 5 *When the paint is completely dry, place a sheet of tracing paper over the painted square. Pencil the letter onto tracing paper and center it within the square, leaving a margin on all sides. Draw light marks on your art paper at the corners of the tracing paper, so you can replace it easily.*

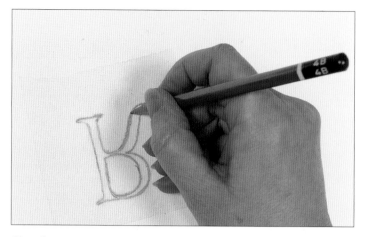

Step 6 *Turn the tracing paper over and use a soft B pencil to draw over the letter. Use an H pencil to transfer the letter to the painted square (as described on page 57). Touch up the resulting pencil lines as needed.*

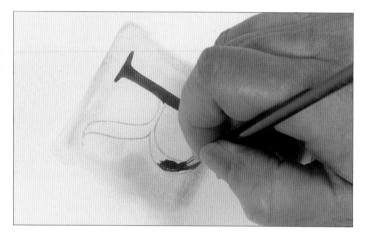

Step 7 *Mix dark pink by adding a small amount of white to red. Use the small brush to paint the letter. Load plenty of paint on the brush and keep a steady hand as you pull the brush toward you.*

Step 8 *Clean up any rough edges of the letter by smoothing them with a layer of slightly thinner paint. Allow the letter to dry.*

Step 9 *Rule the paper, positioning the baseline of the minuscules near the center of the large versal. This style of using an upright majuscule with an italic minuscule is a classic Renaissance combination. Load the #2½ italic nib with deep green gouache to letter the rest of the word.*

Step 10 *Use a pencil to lightly draw the vines of the border on tracing paper. Add leaves, roses, and forget-me-nots. Transfer the vines, large leaves, and flowers. Draw the remaining smaller leaves freehand.*

Painting the Floral Border

Step 11 *Mix medium and light pink; brown; blue-green and yellow-green; plus a few lighter and darker tints and shades of each. Test the colors on scrap paper. Use strips of paper to mask off the area not being painted on your art paper.*

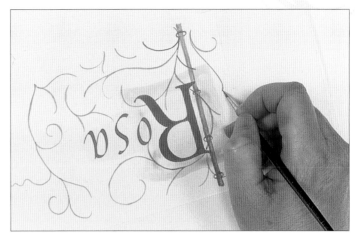

Step 12 *Use the drawing nib or the small brush to paint the vines, keeping the lines sinuous, even if it means straying from the pencil lines. Use thinned brown to paint the pole, and use thicker brown to paint the rose stems.*

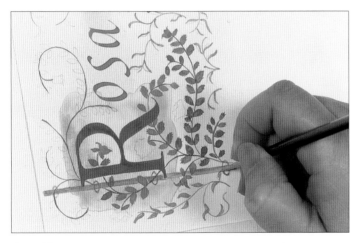

Step 13 *Use dark green to paint the rose leaves, giving the upper edges a serrated look. Paint the leaves of the forget-me-nots using two shades of yellow-green for added dimension.*

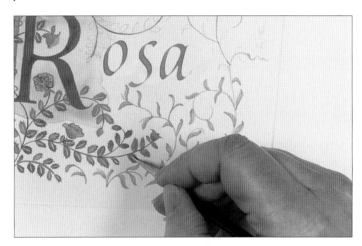

Step 14 *Use light pink to paint the shapes of the roses; then paint the edges of the petals with dark pink and shade the bottoms of the petals with medium pink. With a light tint of green, paint thin center lines on the rose leaves.*

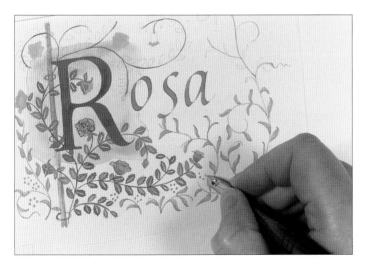

Step 15 *Use the small brush or drawing nib to add light blue forget-me-nots throughout the foliage. Add small yellow dots to the centers of the flowers.*

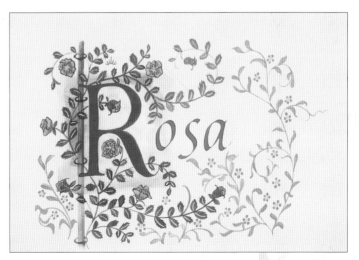

Step 16 *When the paint has dried thoroughly, erase any visible pencil lines.*

Exploring Decorative Techniques

As your calligraphic skills develop, you may enjoy adapting and inventing decorative techniques to use with your letters. Look to both ancient and modern illumination for inspiration. The resulting letters can serve as stand-alone monograms or as versals to begin a page of beautiful, hand-written text using your newly developed skills.

Diamond Background Design

Step 1 Letter a majuscule with gouache using a wide nib.

Step 2 Use a pencil to draw a diagonal grid pattern in the counters.

Step 3 Paint alternating squares of gold and another bright color, such as blue.

Step 4 Add a fine outline around the letter and a decorative border that echoes the shapes of the triangles and squares.

Filigree Design

Step 1 Draw and paint a Lombardic versal. Blue is the traditional color for this style.

Step 2 Use pencil to draw a filigree design around the letter. This is simply advanced doodling, so there is no wrong way to do it.

Step 3 Use a drawing nib to trace over the filigree design with red paint, the traditional color for this style. The center design is a series of comma shapes placed in a radial design.

Step 4 When drawing the filigree, keep your lines fluid and graceful. You will probably not follow the pencil sketch exactly, and, with a little practice, you won't even need guidelines.

Split-Nib Effect with Black and Gold

Step 1 Use a #1 roundhand nib and black paint to write Gothic majuscules. You won't want to use a smaller nib than this; the lines have to be thick enough so that you can stroke within them using the small paintbrush.

Step 2 When dry, use a small brush to add a center line of gold gouache, which creates a split-nib effect. You may need to go over the gold line two or three times to make it opaque. You can also touch up the black paint as needed.

Creating Decorative Borders

Part of the excitement of illumination comes from the creativity you express by adding elements to enhance your calligraphy. Decorative details need not be limited to letterforms. You can add borders, frames, and other colorful accents to your pages. Design elements can range from small flower and leaf shapes to geometric forms.

To begin your borders, draw the outlines, leaves, and shapes using the drawing nib and thinned black paint. After the paint or ink dries, use thinned gouache to paint the designs, so the lines show through. If you use white gouache, you may want to touch up the outlines. Use the small brush and gouache (but not ink) to touch up lines on top of painted areas.

Closing Words with Cari Ferraro

If you're enjoying this book and its projects, you may want to look further for more calligraphic adventures. It's usually easy to find others who are involved in this fascinating art form. You can often find calligraphy classes offered through community education programs—or you may wish to join a calligraphy guild, where you can meet other calligraphers and study under a variety of teachers. Calligraphers also tend to gather for study opportunities at conferences worldwide. Your local library should have additional books about calligraphy techniques, as well as reference books of historical and contemporary illuminated manuscripts. Easiest of all, an Internet search for "calligraphy" and "illumination" can provide you with a range of helpful resources.

Calligraphy doesn't have to end with pen, ink, and paper—it may lead you to explore other art forms and techniques. Modern scribes make liberal use of art materials, including watercolor, colored pencils, resist, metallic leaf, acrylics, and pastels. They also use experimental tools like chopsticks, bamboo pens, and ruling pens. Many calligraphers enjoy making manuscript books and are engaged in the fascinating world of book arts. You might see letters that look like calligraphy in computer-set type, but don't be fooled by a font. Some of the world's best calligraphers design fonts, even adding variable characters to fool the eye. But calligraphy will always be defined as the art of making letters by hand. Through its use, you'll be able to express and share the power of written language.

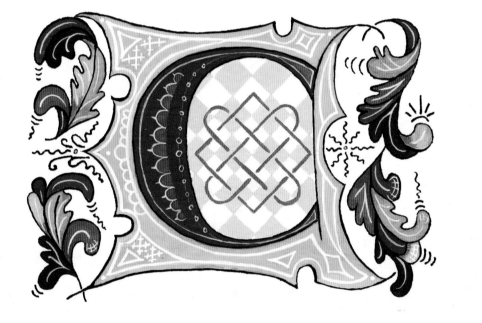

CHAPTER 4
Practice
Sheets

In this chapter, you'll find 13 sheets of practice paper to help you get used to the feel of the pen and the variety of strokes and shapes involved in each alphabet. You can work in the book, use the sheets as guides below tracing paper, or photocopy them. You'll find that most of the practice sheets specify the alphabet that corresponds to the particular guidelines featured. However, you can practice any of the alphabets in Chapter 2 with the Basic Practice Sheet on page 93.

Skeleton See pages 18-19.

Foundational Minuscules See page 20.

30° to 35°

x-height: 4 p.w.; ascenders: 3 p.w.; descenders: 3 p.w.

Foundational Majuscules *See page 21.*

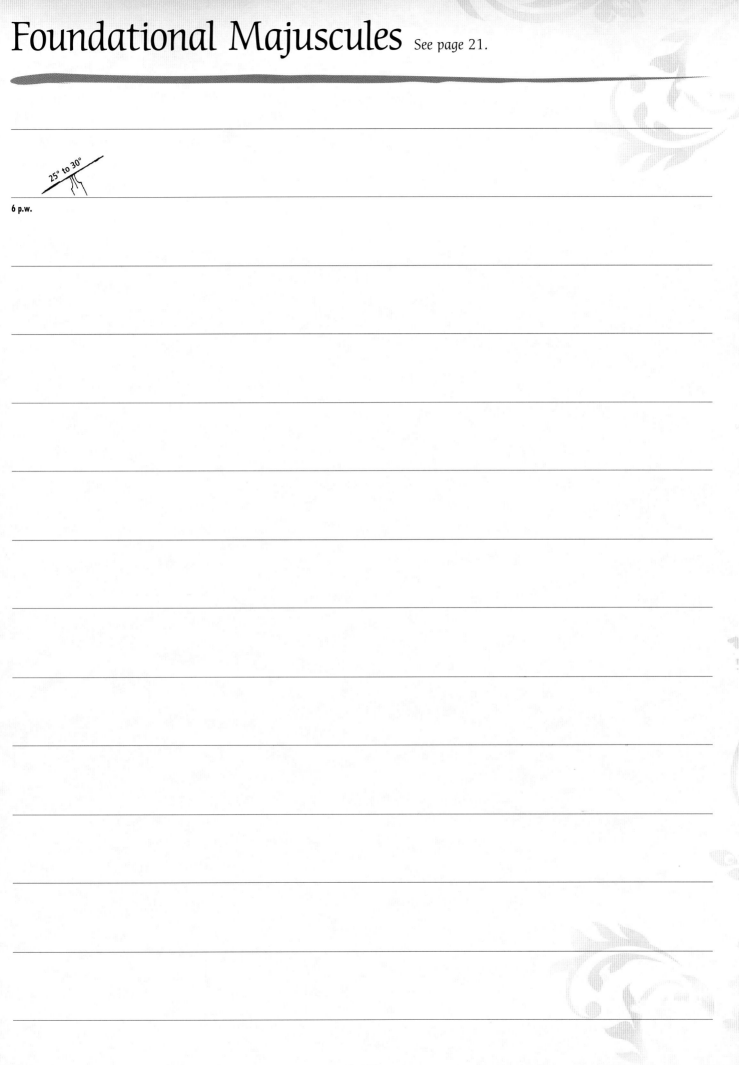

25° to 30°

6 p.w.

Uncial *See page 22.*

5 p.w. 30°

Runic Versals *See page 23.*

0 to 90°; 24 p.w.

Blackletter Miniscules Textura Quadrata See page 24.

4 p.w.

40 to 45°

Blackletter Minuscules: Batarde See page 24.

40° to 45°

3 p.w.

Blackletter Majuscules <superscript></superscript>See page 25.

40 to 45°

5 p.w.

Versals: Roman *See page 26.*

0 to 90°; 24 p.w.

Versals: Lombardic See page 27.

0 to 90° (10 to 15° is a good starting point); 24 p.w.

Italic Miniscules See page 28.

4 p.w.

5 p.w. 40 to 45°

4 p.w.

Italic Majuscules *See page 29.*

40 to 45°

8 p.w.

Basic Practice Sheet

A *aby*

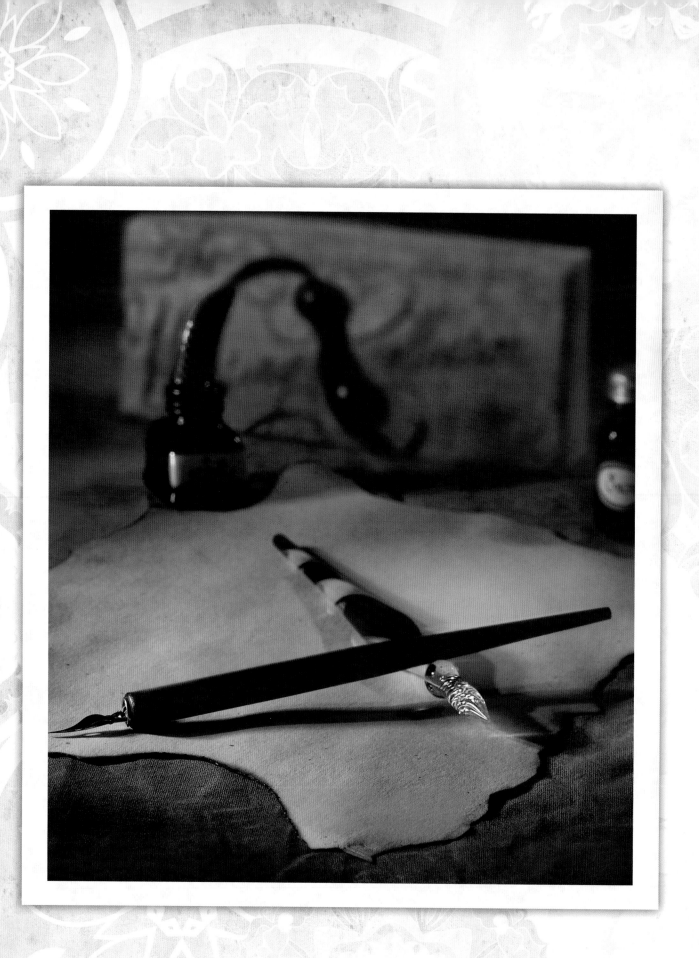

Lettering with
John Stevens

In a world full of digitized letters and standard typefaces, the organic art of hand lettering offers a fresh, artistic, and spirited approach to beautiful writing. In the pages that follow, John Stevens introduces you to a variety of styles—from elegant and timeless to edgy and contemporary. You can use the letterforms in this chapter as inspiration for a range of artistic undertakings, such as creating invitations, formal certificates, personal works of art, and much more.

Introduction to Lettering

Alphabets seem to attract us, even when they're not being used to form words. Their letterforms are an important graphic medium; they communicate and reinforce content. Each style represents a voice. In conservative typography, the voice is rather subtle, but in graphic and illustrative work, it is more prevalent and powerful. Like calligraphy, learning and mastering lettering takes practice. With practice and observation, your ability to add your own variations to the alphabets in this book will increase.

Telling a Story

Lines and shapes contain a content of their own. They speak with a language that we can use and manipulate to influence, alter, or reinforce a message. When applied to letterforms, these lines and shapes tell us a story before we even read the message. Our agreed social conventions have letter styles associated with them. When you see lettering that is fancy, grandiose, or elegant, you may think of a wedding or poetry. When you see blackletter, with its strong rhythms and angles, you may think of church, Europe, or even German beer. An old sign may contain a sans serif "Gothic" that evokes images of Grant Wood's painting *American Gothic* or a general store of the 19th century. When people started to work with letters in this illustrative manner, graphic design was born.

Contemporary Lettering

Technically, the skills required to do this work have changed little until fairly recently. The way it has been done for thousands of years was by physically drawing, painting, or writing the alphabets. Only in the past 20 years have digital tools become a significant factor. Ironically, technology has given birth to some lettering that looks amateurishly hand done, which I call the "no skill, but great commitment look"—the human touch exaggerated. It reflects the individual's need to be different, non-conformist, and expressionistic. I like it, and it is one of many "voices" we can use. Oftentimes I

Roman Letters

think of my work in terms an actor might use. On some projects, it takes me a while to "find the character."

How to Use This Chapter

This chapter features a range of styles that you can use as a source of inspiration or replicate in your personal lettering projects. The letterforms contained herein cover a range from classic and elegant to edgy and personal. You'll learn to exert control over nuances, creating variations on the fly—something that is not possible with computer fonts. Some styles are decorative; others derive their forms by being connected to the subject matter. You can even create variations of the featured letterforms by altering the underlying form, height, or weight, or by adding or removing serifs.

Some styles—like the classic form—are neutral. (You can use Roman capitals almost anywhere, for example.) Others have more specific uses. Some styles require more study and practice than others; however, if you study classic forms, you'll be able to render virtually any other style. Your personality will still show through in your letters, and your freestyle work will be more solid. It is important to remember that these are not fonts: You

Most of the fonts we use on our computers are, or were, based on hand lettering.

don't have just a few selections from a menu, but rather a continuum of lettering choices that are fluid and malleable. Once you master some basic techniques and principals, you will be ready to begin your own creative journey.

Take note of the relationships within each style and the key letter shapes. Anyone can make one impressive letter, but your new skills will come into play when you have to make the other 25 letters to match!

Lettering Art

In my work, lettering is sometimes an independent image; other times it complements a photo or illustration. It may even contain qualities of the photo or illustration combined to look like one idea or thought. I design letterforms for a particular purpose, and this gives me control that one doesn't have when searching through a font menu. Lettering and calligraphy overlap in many areas, but they differ in a few important ways. Calligraphy has gone through many changes in the past two decades, and the lines between calligraphy and lettering have been fading. The difference is subtle, but it comes down to "writing art" vs. "lettering art." Each has a slightly different aesthetic and purpose. I like to think that "writing art" is more related to calligraphy with a performance element, whereas "lettering art" can be done by any means; however, each has borrowed from the other. Almost no one is a purist anymore.

Immerse Yourself

Become a collector of any lettering art that appeals to you, and try to discover what makes a particular piece work. Study from books and attend workshops.

Start looking at all the letterforms around you. You will find many sources on the Web, in magazines, in bookstores, on the sides of classic cars, on food labels, and in movies—just look for them.

It's natural for people, whether practicing their signature, drawing comics, writing a letter, getting a tattoo, making art with words, or working on a business logo, to want to play with and discover what they can do with the shapes

of letters and their arrangement on a page. As long as expressing our individuality in words is important, there will continue to be uses for hand lettering. Once you get started, you may very well become addicted.

Honing Your Skills

Mastery is the same for everything in life: Plenty of practice is key.

Your first attempts at lettering will be focused on technique. But if you want to become a professional, you are better off with a recognizable style than with great technical ability. That is because *you* are the content, so a handwriting that has style and character is worth more than perfectly rendered Roman letters.

—John Stevens

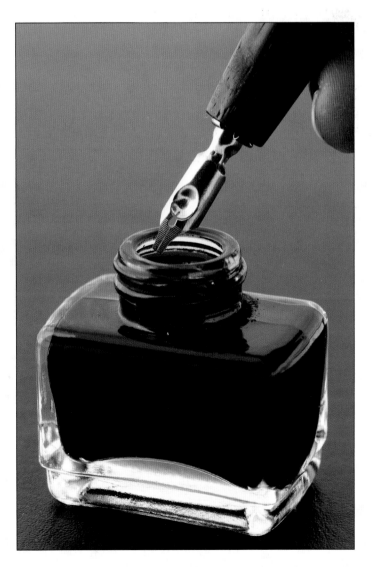

Tools & Materials

Y ou have many choices when selecting writing tools for hand lettering. Pencils are often used for layout, but I usually use a pointed brush, broad-edged brush, pointed pen, broad pen, ruling pen, parallel pen, or markers for my letters. These tools can be used interchangeably, meaning that you can use the ruling pen instead of the pointed brush for a variation on any of the alphabets, depending on your skill level. Some tools have to be modified or prepared. Artists and craftsmen of the past did this routinely, but now we expect to go to the art supply store, remove a tool from its packaging, and have it work exactly the way we want it to.

Below, I mention the brand names that I use because all pens, brushes, and inks are not created equal. There are no industry standards. The information I have included is based on 30 years of experience, but I also recognize that we each have our own preferences. Each tool has a cost-to-benefit ratio. You will be more comfortable with some than you will be with others.

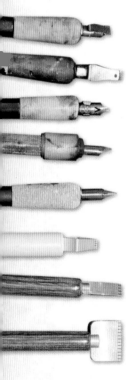

Pens

Broad-Edged Pens

The broad-edged pen may be the easiest of lettering tools for beginners. It's popular because of the natural thick-and-thin ribbon it makes, which has been adapted to the Western alphabet. Broad-edged pens come in the form of dip pens for calligraphy (Brause and Mitchell are good options), automatic pens for larger letters, and fountain pens. Broad-edged pens (sometimes called flat pens) can be used for many of the styles in this book; however, you may have to do a little manipulation with them to achieve some of the desired effects.

Pointed Pens

Pointed pens do not automatically produce thick and thin lines, but rather rely on pressure from the writer to produce variation in line weight. Pointed pens are made from different metals and have differing amounts of flexibility. Preferences vary, so you will have to try both. The White House employs calligraphers that use the pointed pen to create beautiful work for presidential affairs. It can also be used for informal work, but the downside is that it takes a lot of time to learn to control. Line weight variations depend on adding and releasing pressure, so the nibs have a tendency to catch on paper fibers and splatter. This pen requires patience.

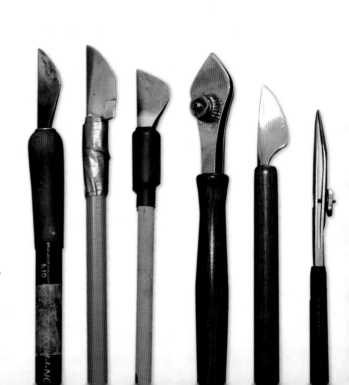

Ruling Pens

This is a forgiving tool and can be quite fun. A ruling pen has a knob on its side that you can turn to move the blades closer together, which produces a thin line, or farther apart to increase the flow of ink. They create forms that seem random and free—the opposite of traditional calligraphy. I usually vary the weight of line by changing from the side to the tip. It is a highly versatile tool, thus I recommend that you have several. You may choose to purchase new ruling pens, but you can also find a variety of shapes and sizes in antique stores, as they used to be part of drafting sets. Ironically, ruling pens were designed to draw very precise lines, but now they are part of every calligrapher's tool kit as a tool that liberates and allows for experimentation. The downside is that you must learn to put the components together correctly or you could end up with a mess.

Brushes

Pointed Brush

The pointed brush may be the most versatile lettering tool available. It comes in a wide variety of shapes, sizes, and bristle lengths. I use Chinese, Japanese, and sable brushes (Winsor & Newton™). Like the ruling pen, the pointed brush is a wonderfully expressive tool open to wide variation. The characteristic "brushmark" is highly desirable. You can create work that has interesting texture and line with little practice, yet it can be challenging to exert control and produce consistent work. Many people turn to this brush to create illustrations or logos just for the mark-making element, even though they plan to digitally manipulate the strokes.

Broad-Edged Brush

The broad-edged brush is a versatile tool that shares the comfort of the broad pen but is good for surfaces that are not pen friendly, like fabric or thin Japanese paper. It's also a good tool for creating large letters, especially on a wall. The downside is that it has a fairly high learning curve and is not ideal for beginners. Broad-edged brushes have a ferrule (the part of the brush that holds the bristles onto the handle) that is either flat or round.

Inks & Pigments

Inks and pigments fall roughly into dye-based, pigment-based, and carbon-based categories. Carbon and pigment come mixed with water and binder. Some are waterproof, but they use a binder that is not generally good for your tools, so be careful. Carbon-based inks are permanent, as they don't fade over time. You can also grind your own ink with an ink stone and a Chinese or Japanese ink stick. I generally prefer the Japanese ink sticks. Higher quality produces better ink, and one ink stick can last for many years, so they are very economical. You can control the density and blackness with this method, and there are no harmful additives or shellac as there sometimes are in store-bought bottled inks. I recommend Higgins® Eternal Ink. Dye-based inks should be used for practice because they are loose, which can lead to an interesting effect in writing. They will not clog your pen, but your work will fade over time.

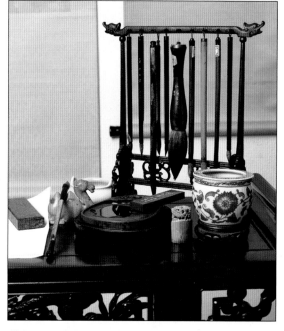

Other pigments you will use are gouache, watercolor, and liquid acrylics. Gouache and watercolor are similar, although gouache is more opaque and dries to a velvet flat finish. Watercolors are transparent and are good when you want to see some variation in the color.

Chinese writing brushes, ink stick, and ink stone

Paper

The subject of paper is vast, especially now as manufacturers are able to make lower-quality papers appear better than they are. Some paper may look good, but it may bleed once you scratch the surface with your pen.

Paper can be broken down into three categories: practice paper, work paper, and paper that renders special effects. Lettering artists put careful consideration into the paper they use for their finished work.

Bond paper that is smooth and doesn't bleed is most useful for everyday use. For practice, you can use brown kraft paper or a cheaper bond paper (as long as it does not bleed). Higher-quality bond paper is worth the price. Canson® Marker Pad contains a smooth, white paper that is nice to work on and is somewhat translucent, allowing you to slip a sketch underneath for a guide.

Once you're ready to move beyond practice paper, you might want to try Arches® Text Wove and Arches Text Laid papers. They are durable with a slight "tooth," which may lend a nice quality to your letters.

BFK Rives is another good brand. Its papers are well suited for finished work, whereas bond and kraft papers are the best choices for practice. Every so often it is a good idea to work on nice paper, as it affects the quality of your work.

Specialty papers include handmade papers, colored papers, and rough watercolor paper, which can be used to achieve interesting, textured edges or contours in your lettering.

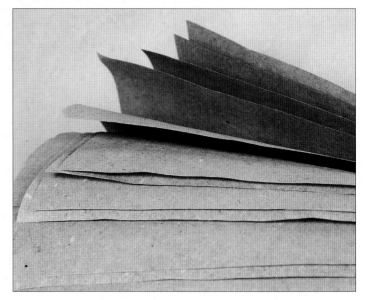

Kraft Paper

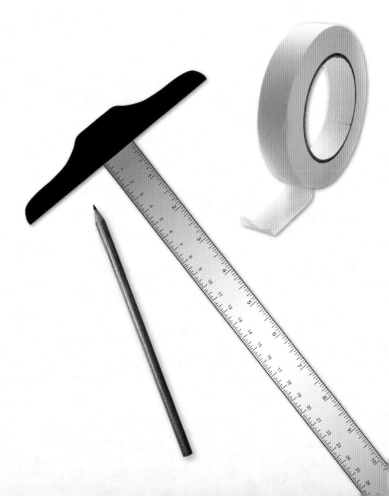

Specialty Paper

Bond Paper

Extra Materials

There are several other tools you will want to keep on hand: pencils, erasers, a straight-edge (T-square), tracing paper, white gouache for retouch if necessary, cutting tools, markers, masking tape, mixing trays and palettes, and smaller, inexpensive brushes for mixing colors and loading pens.

Fundamental Elements

The first important technical elements for a beginner of hand lettering to learn are hold, stroke, and rhythm. You must learn to do these things correctly before you will be able to write consistent letters. It takes practice in order to work with confidence. A stroke should not feel hesitant, and the shape the tool itself is prone to create should be understood and applied to the letterform that you are rendering.

Hold

In general, brushes and pens should be held fairly vertically, with the back end of the writing instrument pointing toward the ceiling. Avoid pointing the handle toward the wall behind you (exceptions to this rule involve some ruling pen techniques). Most beginners hold the brush or pen too flat. The hold is a gentle grip between the thumb, index, and middle finger (for support). You can achieve great results no matter what technique you use; however, you must compensate for an incorrect hold with the way you move the brush or pen, which artists often do. Great art has been produced regardless of the technique. I like a vertical hold because it is the best starting point from which to move in any direction or flip to any side of the pen or brush. If your hold is flat with a locked grip, it will be hard to be fluid later, and you may have to unlearn some bad habits.

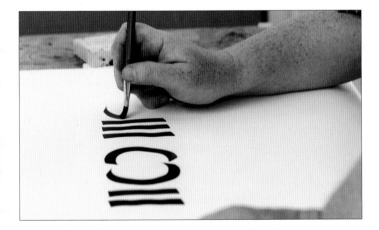

Stroke

Generally, stroke order should move from left to right, from top to bottom, and should attack vertical lines before horizontal lines. If you think a particular portion of a letter should be done in one stroke but it's just not working for you, try two strokes. Be careful and take your time.

The control of ink or pigment—getting the flow and the amount of ink correct—is a challenge for beginners. It's a combination of practice and knowing a few principles. It is a balance between having plenty of ink for flow and having a little bit for control (no blobbing, puddles, etc.). Because all inks are different, I usually have a palette or swatch of paper on which to test my pen or brush before I touch it to the page. With pen, I dip to load when the work is loose and free, and I load the pen using a brush when I must control the amount of ink on the nib to maintain consistency or to produce the hairlines on thin strokes. (See "Loading the Instruments," page 106.)

Dab a broad-edged brush on a palette after loading it with ink in order to shape its bristles and move the pigment to its tip. A pointed brush can be dipped and used for writing immediately, or dabbed on a palette first if the artist chooses to err on the side of caution.

Rhythm

As you begin to create strokes and acquire a feel and confidence for making the most basic shapes (and doing so repeatedly), you will start to develop a rhythm. Rhythm is a natural process that helps unite the letters that are strung together. In lettering, our tasks start to become rhythmic, thereby gaining fluidity and momentum.

When we say we need to "warm up," we are referring to this natural phenomenon. Start with verticals; then move to horizontals, curves, and diagonals, and then try your hand at "key letters." (See "Key Letters," page 102.) Think about geometry and the quality of drawing. It might take some time to feel confident with the tools, but it will come together if you hang in there.

Common Characteristics

Each tool has a unique technique associated with it, yet there are several aspects that overlap. Lettering, like calligraphy, has some characteristics common to most styles:

- Interesting line and characteristic shapes
- Proportions
- Variation in line
- Underlying structure
- Serif or sans serif (see box at right)
- Joints and connections
- Weight

Serifs

Serifs are the details, or short lines, that stem at an angle from the ends of the strokes that form a letter. When an alphabet does not have serifs, it is known as "sans serif."

R R

sans serif serif

Key Letters

When you are learning a new style of alphabet, it's best to start with the "key letters." These letters will serve as your key to the straight and curved lines that are consistent throughout the other letters of the alphabet. For most alphabets, these letters are **i** and **o**. Next, practice **d**, **b**, **p**, and **q**, and then progress from there. When you group letters by shape, it's easier to create unity. This methodical practice will help you to learn the inner relationships that make the letters in the alphabet go together, instead of seeing the letters as 26 different shapes. Key majuscules are **H**, **O**, **N**, and **E**. You can also organize letters into width groups. You will begin to see that the **m** and the **n**, as well as the **P** and the **R**, are made up of the same genes.

While learning a new alphabet, also take note of proportion. Classical letters have precise proportions, whereas unconventional letters usually do the opposite to create that "unskilled yet intentional" look.

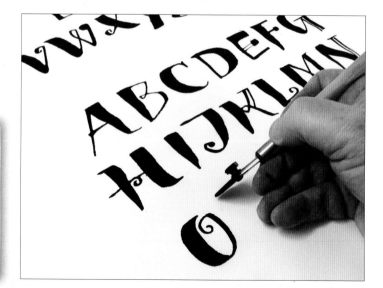

Key Letter Groups

i m o	b d p q g
a e c	k v w y z l
h n u r	f t s j

Techniques

The scribe of the past would cut a reed or quill pen, thus shaping the nib to his or her preference. You may find that you need to modify tools to your preference as well. For example, metal pens sometimes have a polished and slippery feel. When this occurs, roughen the tip with some very fine sandpaper. As you master the techniques in this section, you will discover ways of modifying your tools that will make them work to your advantage.

Broad-Edged Tools

With the broad-edged pen, start with simple, even strokes and hold a consistent pen angle. Most beginners start with a hold that is too tight and shallow, but then should develop a hold that is more vertical. Even though many of the alphabets in this section are informal, you will find that it is helpful to use a T-square to draw straight lines on your lettering surface.

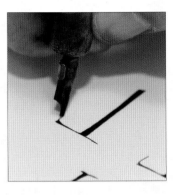

▶ **Cornering** *When cornering, use only the corner of the pen's nib to create a thin line or to fill in detail. This technique is often used for hairlines and sometimes for ending serifs.*

Broad-Edged Brush

The broad-edged brush is somewhere between the broad pen and the pointed brush because you can borrow influences from both sides. Use it as a broad pen or use it as a "hybrid" brush.

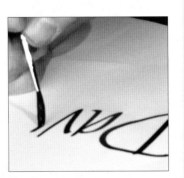

Broad-Edged Brush Hybrid

This is an example of using a drybrush technique with a broad-edged brush to create an interesting effect. By doing this, the brush exhibits qualities of both a pointed brush and a broad-edged brush.

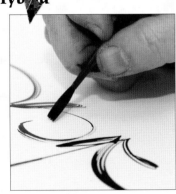

Waisting

Waisting *Waisting is accomplished with a slight quarter roll, or counter clockwise twist of the pen midstroke. This will give the line more visual interest by making it concave.*

straight stroke

waisted stroke

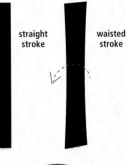

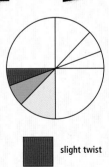

slight twist

1/8 turn

1/4 turn

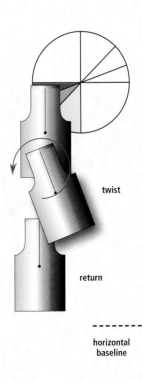

twist

return

horizontal baseline

Ruling Pen

The ruling pen is a play tool for many. Sometimes it seems as if you are violating the paper, as marks are forceful and the paper fibers can get roughed up. There is no right or wrong way to write with this useful tool.

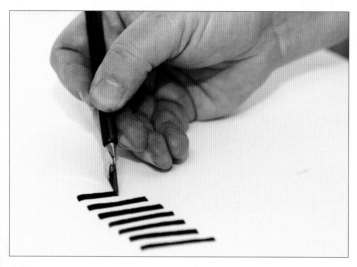

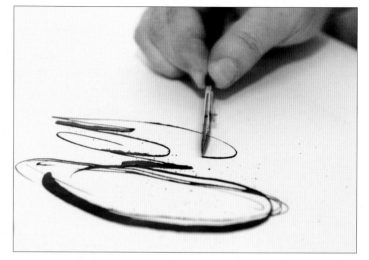

Folded Ruling Pen *The folded ruling pen creates a thin line when you work with just the tip, a thick line when you use its side, and every line variation in between as you move from one position to the other.*

Experimenting with Marks *Here I am using what I call a flat hold, where I hold the pen as I would hold a knife at the dinner table. Although it is important to gain control of the ruling pen, the trick is to make the marks look slightly out of control.*

Pointed Pens

This type of pen is associated with "copperplate" and Spencerian script, but it can be used for contemporary handwriting as well, especially when the tip has been modified. Putting a slight broad edge on a pointed pen is a modification I commonly make by sanding it down with an Arkansas stone. Another way to change the effect of a pointed pen is by using the pressure and release method (at bottom right).

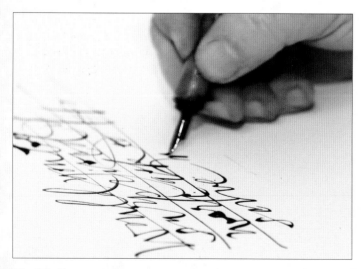

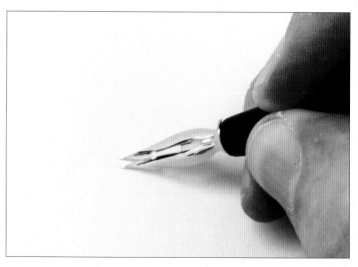

Flexible Pen *Traditionally, most calligraphy was done with either a pointed pen or broad-edged pen. Both create "shaded" lines, but they achieve the shading in different ways: A pointed pen employs pressure, and a broad-edged pen changes in direction. Here I am adding pressure to a flexible pointed pen, which adds weight to the line.*

Pressure and Release *For this technique, add and release pressure applied to the point of your pen, which will spread and unspread the two blades. This motion controls the flow of ink onto the paper and allows you to create variations in line weight.*

Pointed Brush

The pointed brush is full of variables and thus may be a little unnerving at first. I think it is the most valuable tool in many ways because you can draw, paint, and write in a variety of media and on almost any surface. Direction, pressure, and speed all affect the line you make with the pointed brush. The brush can be held upright or on its side; you can work with the point for thin lines or the broader base for thick lines. Develop a feel for this tool by practicing a variety of strokes.

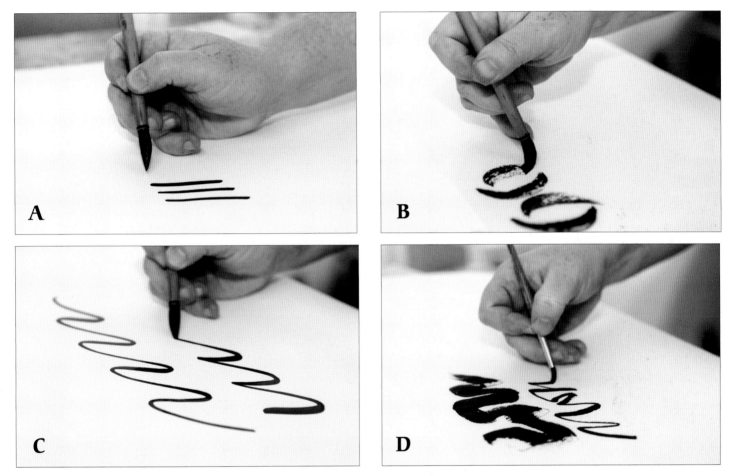

Pointed Brush Holds *These photographs show the common approaches to handling the pointed brush. You can either work on the tip of the brush (A), work on the side of the brush (B), or use a combination of the side and tip of the brush (C). You can also create variation with pressure (D). There are different types of brushes, and the shapes, sizes, and bristles all make a difference. Both the paper you use and the method you employ to load ink into the brush will also impact the final result.*

Chinese Brush

The Chinese brush offers more variation in its stroke than other pointed brushes. Some Chinese brushes exert control and others are more like mops, dragging along the paper and leaving a brushy mark that gives (or reveals) character. Just like the pointed brush holds shown above, there are several holds for the Chinese brush: holding the brush handle vertically, holding the brush handle at an angle, working with just the tip, and working with splayed bristles.

Loading the Instruments

In fine writing, where precise control over the flow of ink is extremely important, use a paintbrush to load the pen with ink. To maximize consistency, I load the ink with a medium-sized brush. If I dip a pen, I almost always test it on a scrap of paper before committing to the final piece. In lettering, you must be able to predict what your tool will do—at least to some degree. Once you have established control, you can take more chances. Otherwise, it is simply a matter of personal preference.

Beginners have trouble judging ink dilution. If you are dipping and you load too much ink into the pen (in an attempt to extend the duration of your writing time without having to reload), you will end up with blobs. If you do not load enough ink, you will be reloading too frequently, which creates a break in rhythm. Practice is the key to fine tuning your loading skills.

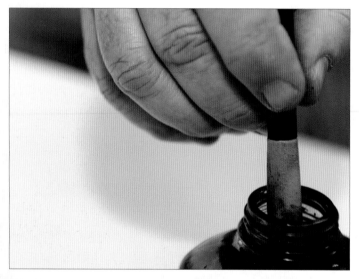

Dipping *For more spontaneous writing, you can get away with dipping the pen in the ink. Just be aware that the first stroke you make on the paper will release the most ink; subsequent strokes will release less and less ink.*

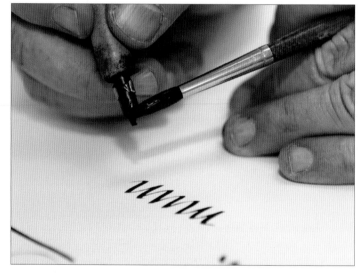

Using a Brush *Begin by taking the loaded brush in your left hand (if you are right-handed). If writing at a small size, carefully touch the tip of the pen with the brush and load a little ink into the reservoir. How much ink you load depends on how small the writing, how fine and absorbent the paper, and how fluid the pigment (ink).*

Loading Colored Ink & Paint

When working with color, you will dilute your ink or paint with water to varying degrees depending on the effect you want to achieve. Very controlled (fine) writing can not be expected with loose, watery ink. I often grind my own sumi ink for control. Higgins Eternal Ink has a controllable consistency, but you may want to dilute it if you are writing quickly. I find that an eyedropper is a handy tool for loading my pen when I want to create multicolored marks. (See "Making Multicolored Marks," page 107.) The variables to consider any time you are diluting ink or paint and loading your writing instrument are the type of pen (or brush) you are using in relation to the size of the lettering, the density of the ink pigment, and the thickness and absorbency of the paper.

Working with Color

Once you have become accustomed to lettering, and after it has become rhythmical to you, you can advance to working with paint. It is a slower process that involves interrupting your flow as you try to control the color, so it's best if you have first acquired a confidence in lettering.

There are several ways to work with color in calligraphy and lettering. Pictured at right is a watercolor technique. If the final work is to be framed, then you should use paints with lightfast pigments, as they don't fade as quickly. If you choose not to use high-quality watercolor, you can use liquid acrylics. You can even use gouache paint, although the result is a bit muted, it's still lovely.

Try to keep each stroke on the paper wet, allowing the next stroke to bleed into it a bit. If you have painted with watercolor in the past, the process is similar; work wet-into-wet. It's a loose technique, but you can develop a sense of control with practice.

I used this technique not only to bring color into a piece, but for its organic qualities as well. It has a life of its own and results in unique variations, as opposed to flat colors.

I recommend that you try colors like turquoise, blue, and purple as a base, with touches of orange and yellow to produce some exciting greens. For a warm palette, use red-orange or burnt orange, sepia, deep red, and purple with a touch of yellow. You should experiment, but be forewarned: Do not use every color in the rainbow in the same piece unless you want it to be garish and busy. By limiting your palette, you should see pleasing effects right away. Experiment and write down what works for you so you can do it again and learn from your mistakes.

Making Multicolored Marks *You will need two jars of water: one with clean water for loading your pen and mixing paints and one for rinsing your pens. Start by dipping your pen in the clean water. Then use an eyedropper to add a bit of diluted watercolor to one side of the pen (such as blue); add another color to the other side of the pen (such as green). Then test your stroke.*

TIP

BRUSH CARE: Never load your brushes or pens with anything that is waterproof, and always wash your writing tools thoroughly when you are finished with a session. Never leave a brush with its bristles standing in water or ink.

Paths to Success

In music, you learn both the instrument and the notes at the same time. Lettering is similar in that you are learning the tool and the subject of lettering simultaneously. In order to become a master of both, there are a few things to keep in mind.

Practice!

Above all, diligent practice will help your lettering skills flourish. As you get a feel for the tools you are using, you will gain confidence. Start by copying something carefully, such as an alphabet or a page of text. Observe the difference between your trials and the exemplar. Careful study of each letter is necessary. Practice with the exemplar right in front of you. Do not trust your memory at first. I recommend that you take plenty of breaks and even draw the letters so you are really "seeing" each shape, line, and curve. People often confuse "looking" with "seeing." Everyone looks, but not everyone sees. It takes time and effort to see, which is why drawing is so helpful. It slows you down, turns off your "naming" mind, and lets your eyes do all the work.

People often practice for hours at a time with days between sessions. Do the opposite: Hold short but frequent practice sessions. Learning is the result of observation, taking notes, and repetition at frequent intervals. Portable brushes and pens are available, so you can spend some of your free time practicing in a notebook. Simply having the tool in your hand and making marks will help. If you become bored or frustrated, play with the tools. Don't try to do anything specific; just see what happens. This is how you balance that desired look you may have in mind for your finished work with letting your creativity flow.

Having said that, you can check your own work in these ways: 1) Always have the model right in front of you for comparison. A common mistake students make is burying the exemplar as they concentrate on gaining control. This leads to practicing the wrong strokes over and over.
2) Create a map for yourself. Cut out your best efforts and place them next to the model. Draw or trace the model to make sure you are really "seeing." From time to time, be brave and hang what you have done on the wall to really "see" it. I guarantee you will view your work differently by doing so.

TIP

Remember to be methodical about your practice. Date your practice sheets and keep them—it's important that you notice your progress!

Finding Inspiration

It's also a good idea to start a file of clippings that inspire you. This includes work you like, lettering in books and magazines, or fonts from the web that appeal to you. Old signage is disappearing, so get out that digital camera and snap as many photos as you can. Some sign shops still produce hand lettering. They are a friendly bunch, so call and see if you can stop by to see what they do. Be mindful not to interrupt working people; you will have to judge based on the friendliness of your host. But this might just be the last generation of sign painters, and they have a plethora of tips to share about drawing letters.

Getting Started

As soon as you feel confident (don't wait too long), I recommend that you complete a project. Make something with what you have learned. There are many ways to apply your newfound skills: You can make an alphabet page, a poster, a book, a postcard, a logo, or a sign; letter your mailbox; draw your favorite quote; or design a program for school, church, your band, or other organization. Simple design (organizing lettering on a page) is more valuable than complex design in the beginning.

Not only will you then have a finished work of art, but your knowledge will be enhanced by completing a project. It is the secret of "anchoring" your skills and knowledge into your subconscious. Think of it like exercise: Your mind and vision will expand from creating and completing a work of art.

Whether the work is perfect is irrelevant; it is much more important that you finish and then move on to the next project. This is how you gather momentum. Over time, know that you will improve immensely through practice. This is the advice you would give your children, so make sure you take it yourself.

Mastering the Art of Lettering

Ask anybody who does lettering or plays an instrument and they will tell you that it is an ongoing process. You are never done learning. This is good news, as people as talented as Leonardo da Vinci have made it their life's mission to study and learn about infinite possibilities. Da Vinci believed that one's vision should be ahead of his or her ability. You should not strive for perfection; you should instead strive for excellence.

"Have no fear of perfection—
you'll never reach it."
—Salvador Dali

www.calligraphycentre.com

iPhone Wallpaper by John Stevens

Furthering Your Education

If you are striving to become a professional lettering artist, additional education is recommended. A classroom setting will provide even more inspiration, and you will be able to see the process first hand. More important, you will receive feedback from peers and see how other students' progress.

The following pages feature a collection of models from which to work. After many years I have attained a level of excellence, but I too am still learning. Enjoy the journey!

Classic with a Twist

Classical lettering is refined and beautiful, and its letters have withstood the test of time. One of the most celebrated examples of this style can be found at the base of the triumphal Trajan Column in Rome. The Trajan Inscription contains the most elegant forms of Roman lettering, and it was written nearly 2,000 years ago. Imagine that. We still use the letters of the Roman Empire! This is because you cannot improve them—you can only alter them. They are considered to be the highest in the letterform pyramid. I recommend that any serious lettering artist do a thorough study of them. They are a fine balance of form and function. They are (unfortunately) also difficult to replicate well. In this section, I have included some personal variations that are not as difficult to create as the Trajan letters, but exhibit some of the same elegance. They are done with a broad-edged brush or pen. Variations can be found in history from 2,000 years ago until present. These letters were studied in the Middle Ages and during the Renaissance era, and they are still studied today.

There are several ways to approach Trajan variations: written, drawn, or built up with broad or pointed tools. In writing them, you will learn a few special techniques that will be useful for other hands as well. My purpose is to share methods that are not too demanding with the assumption that you may not want to be purist, but rather that you will want to create beautiful letters that are placed well on a page.

Tool Box

Broad brush
Broad-edged pen
Modified pointed pen
Ruling pen

Zenful

The Roman Empire's monumental caps are still the standard of excellence today, and they require a great deal of effort to learn and replicate. This adaptation is an elegant and less difficult version of the Roman Imperial Capitals. Zenful is a narrow Roman alphabet without serifs, with highly modular shapes in its curves, and a soft triangular motif. I have been developing this alphabet into a typeface (font) for the last four years. This alphabet has strong links to classic function and form. I created these letters using a broad brush with a round ferrule.

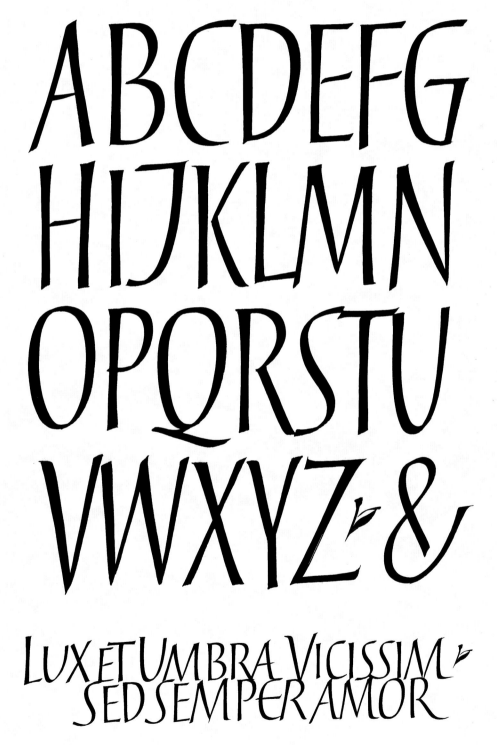

"Light and shadow by turns, but always love."

Latina

Latina letters are playful as they bounce on the baseline, yet they contain the elegant lines of Roman capitals—delicate and airy. I created these letters with a broad-edged pen using a few techniques that will take some practice to perfect: twisting, cornering, and pressure and release. (See "Techniques," page 103.) You have the choice to work with any of these techniques once you are familiar with the forms. For me, my choice of technique depends on the size of the letterforms and the look that I want to achieve.

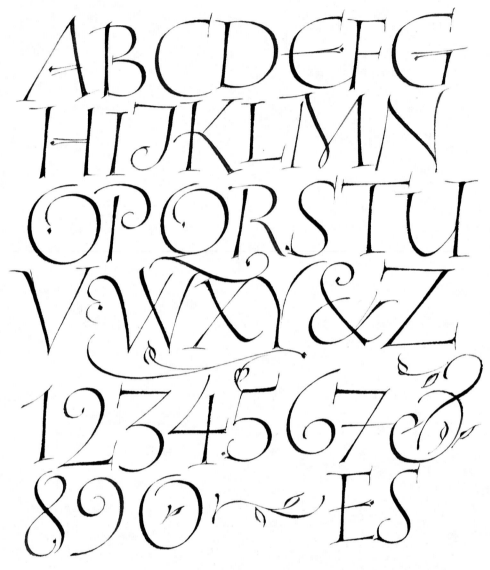

(See "Techniques," page 103.)

A Less Strenuous Method

This Latin phrase was written with a pointed pen that I modified by shaping the point to a small, broad edge with an Arkansas stone. This helped the pen to function as both a pointed pen (flexible width) and broad pen. I created these lines by simultaneously building up the letters and using pressure and release.

"When you are steeped in little things, you shall safely attempt great things."

Libretto

Libretto is a flowing script with strong calligraphic leanings, which serves as a basis for my other ruling pen alphabets and for gaining control of the ruling pen. Start by practicing the straight and curved lines that form this alphabet. Then move on to **O**, **G**, **C**, and **Q**. Once you've mastered those letters, move to **B**, **R**, and **P**, and then move on to the rest of the alphabet. In other words, you should warm up with families of letters rather than start with **A** and work your way to **Z**. You want to feel the strokes by repeating them. Once you're warmed up, you can move to words and continue to work on individual letters that are giving you trouble.

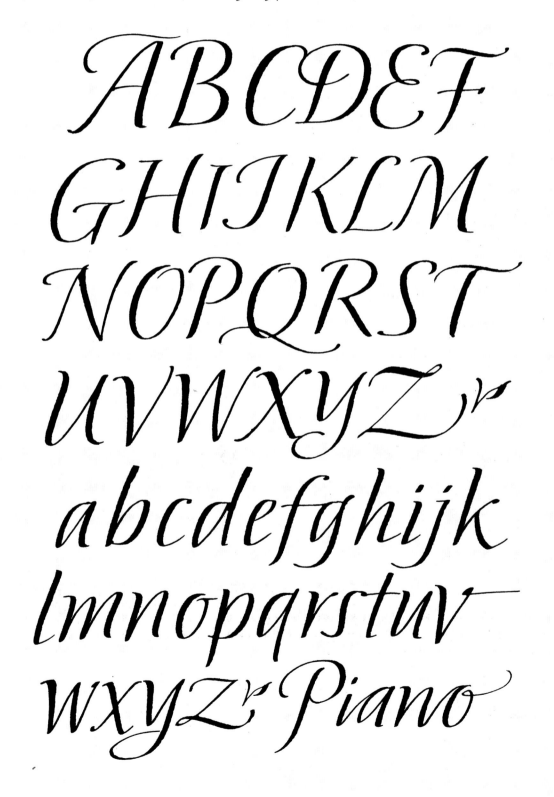

Brushstroke

If an artist wants to make letters by hand, oftentimes they would like the lettering to have that "hand done" touch. With the brushstroke method, the letters display the characteristics and changes in transparency of the animated stroke.

The brush continues to be popular—partly because of its versatility and partly because it is a liberating and expressive tool. A brushstroke can communicate everything from power to delicacy and has a very long heritage—especially in the East. The Chinese and Japanese (along with other Asian cultures) have developed writing to a very high level, and the brushwork in the best of Asian art is deserving of study and admiration. Abstract expressionist painters were heavily influenced by the powerful brushstrokes of the East, where the way each stroke is executed is a high art. In the West, the brush is an experimental tool for creativity.

Even when not being wielded in a traditional manner, the brush is still a great mark-making tool. Simply by viewing its mark, one can see where the stroke started, its speed and direction, and where it ended.

The most challenging aspect of learning the brushstroke is becoming accustomed to what the stroke wants to do and absorbing this into your subconscious, which will allow you to create with its natural shape. When you pick up the brush, you will discover it is not the easiest tool to control—you must become familiar with its "inner rules." (See "Pointed Brush," page 105.)

Tool Box

Pointed brush
Broad brush
Large Chinese brush

Anime

Written with ink and water to achieve a variety of tones, Anime is basically narrow and medium weight, with the occasional wider letter and heavier weight stroke. If you are consistent with the basic rhythm, these two variations will go a long way to giving the feeling of variety and—depending on the quality of your strokes—a degree of individuality. Pressure and release in rapid movement is necessary to create variations in each stroke.

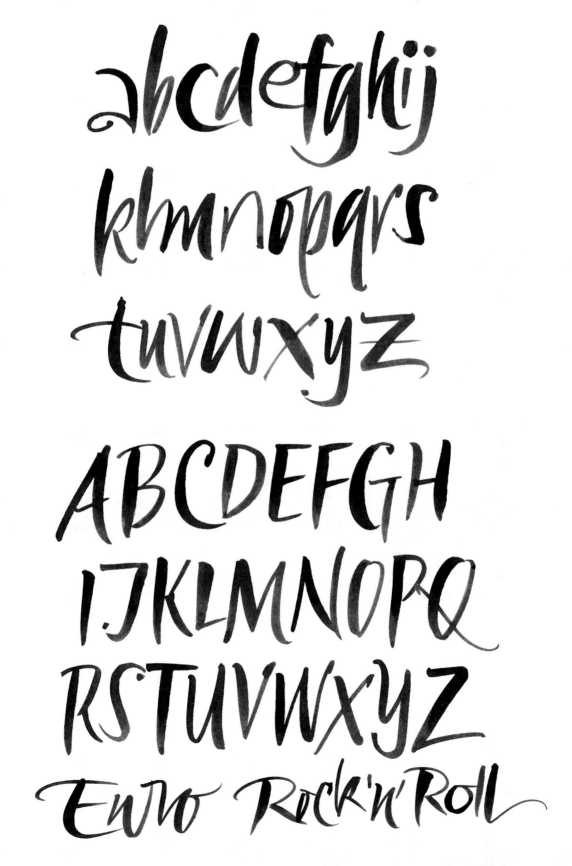

Beijing

For this alphabet I used a large Chinese brush. Allow the bristles to make their characteristic marks by finding the right balance of ink loaded in the brush according to the paper's receptivity. Some papers absorb a lot of ink (Japanese papers are sensitive in this way and will help capture every nuance of stroke), but it is possible to get interesting effects on rough watercolor paper or Arches Text Wove as well. You should experiment on all types of paper.

The basic strokes are as follows: press, move, stop, then lift to make a bonelike stroke. Or you can press and move while lifting slightly to produce a stroke that tapers off. It will take some practice to feel free in your movements, but this type of brush makes very characteristic marks, so it should be fun. In this alphabet, the side of the brush is used more than the tip, occasionally "squashing" the hair when the ink is running out to create rough drybrush marks.

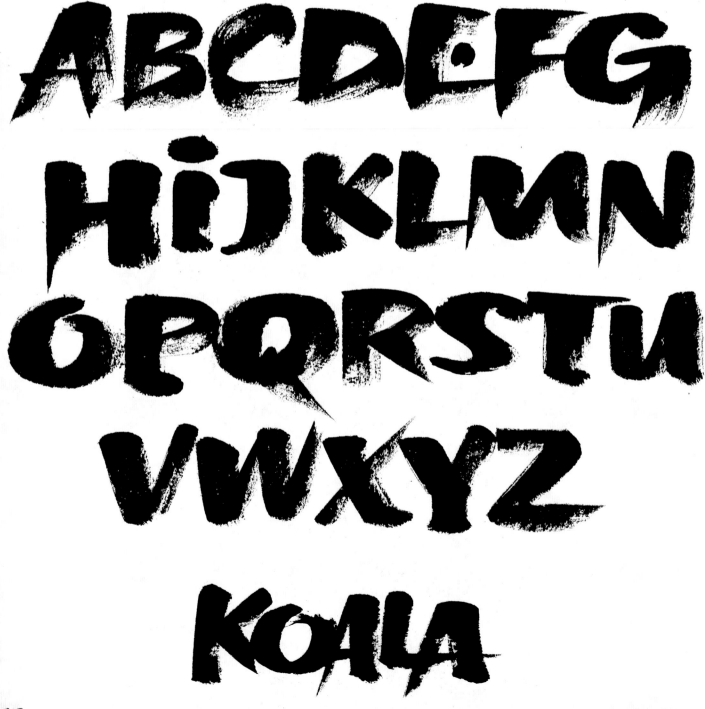

Fresh

This energetic alphabet, which I formed on Japanese paper, is all about finding a good match between ink and paper. Any pointed brush should work for you, but remember that every brush produces a different result. I like to collect brushes and learn the characteristic mark of each; then I choose based on my experiences. Write these letters quickly, keeping in mind that rhythm and energy are the important factors in this style. The strokes are a mix of the side and point of the brush, so practice several holds and stroke variations to learn what works for you.

abcdefghijklmn
opqrstuvwxyz
ABCDEF
GHIJKLMNO
PQRSTUV
WXYZ
Bravo

Fun & Funky

This lettering is unabashedly expressive. It is lettering that begs for attention. It is less disciplined than classic-inspired hands, and presently it's a bit trendy. You can use these styles in place of typography, where it complements the perfection of the computer with a human element. There is a culture to this type of work, and it is mostly associated with youth and creativity. (Picture your high school notebook.) You can draw or write these letters with any tool. I prefer the ruling pen, but you can use any instrument with which you are comfortable. Once you get the hang of the basic rhythm, you can invent your own alphabet. You do not need every letter to be crazy or different. In order for the variety to work, you must establish some order or unity to the letters. That might sound funny, but you get more "pop" on your creative play if you restrain in areas to provide the stage, or backdrop, for the drama.

Tool Box

Broad-edged pen
Pointed pen
Modified pointed pen
Ruling pen
Folded ruling pen

Funk 49

I created Funk 49 with a folded ruling pen. The characteristic stroke has a taper, and the weight feels a little random. Despite this, notice that it still has a nice movement and rhythm. Using the side and tip of a ruling pen are the two basic moves you will employ. The advantage of the ruling pen is that it does not create fixed-width lines, thereby allowing you to create interesting shapes. Unfortunately, this "advantage" is also the downside, as you need to learn to control the pen before finding consistency.

ABCDEFG
HIJKLMN
OPQRSTU
VWXYZ&
abcdeffg
hijklmno
pqrstuv
vwxyyez
Super

Saturnia

I created Saturnia with a ruling pen, but you could easily create these letters using the cornering technique with an automatic broad-edged pen. This is a mix-and-match alphabet hung on a structure of square-shaped, narrow letterforms, with the occasional wide letter thrown in. As in drawing, fantasy can be introduced at any time.

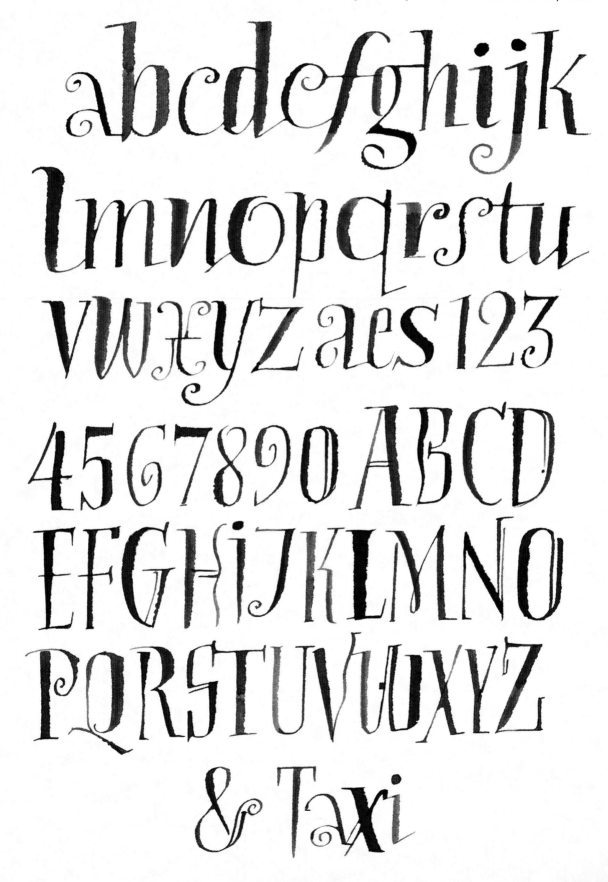

Polyline Pile-Up

Polyline Pile-Up, which pairs a doodlelike quality with sophisticated play, is a good match for the ruling pen. Characterized by lots of movement and personality, these letters can also be created with a pointed pen or pencil. As in any other alphabet, one must grasp the idea of dynamic balance (the amount of black versus white that each letter contains) with a touch of uncomfortable variation. The lines dance around the narrow, squarelike structure that makes up each majuscule. This alphabet serves as a good way to both practice and play at the same time.

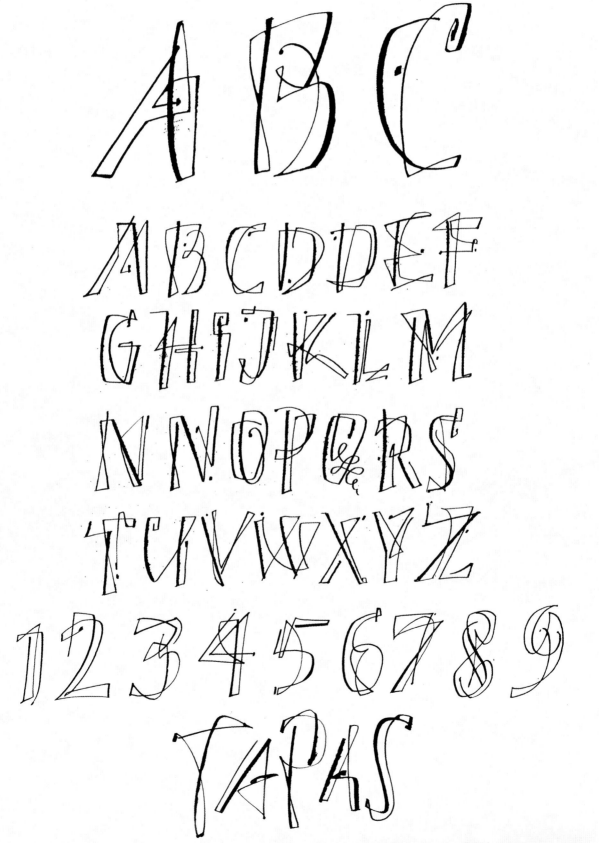

Edgy

Edgy styles are sophisticated yet a bit aggressive, or "forward." This lettering has beauty but does not fall into the "pretty" category that is normally associated with calligraphy. This group has calligraphic underpinnings but seeks to put more action and expression on the page. Many of these alphabets can be created with any writing instrument, with each tool producing different variations. Notice the weight placement: Broad tools will place the weight at a low-to-high axis, whereas the ruling pen and pointed brush will do the opposite. I prefer to combine the two influences to create "hybrid" type effects. I don't recommend that you do this at first, unless you have great visual judgment. It takes a while to learn the rules and know which ones to break. When you want to create lettering with a contemporary feel, this style is a good bet.

Tool Box

Brush
Broad pen
Modified pointed pen
Ruling pen

Manic

You can replicate this alphabet using a pointed pen or a ruling pen. Focus on creating a balance between strokes that repeat and those that introduce variation. Also be mindful of the dynamic balance (amount of black versus white that each letter contains). The letters feel a bit unpredictable, yet they harmonize. Try using a flexible pointed pen with a broad edge to create an exciting stroke that will produce a bit of splatter. Broken pens work as well. Also, your first efforts are likely to be too busy—so think to yourself, "Less is more."

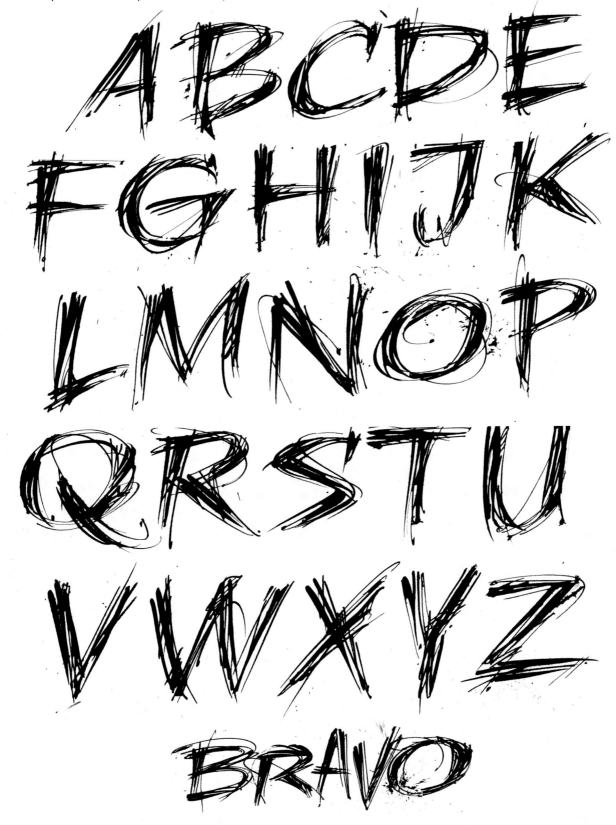

Boundary

Boundary is a pen-written script in a contemporary, upright italic form. It is a cross between italic and an upright cursive, with more movement and a less predictable weighting pattern than straight italic. It is best to begin writing this alphabet with an automatic pen.

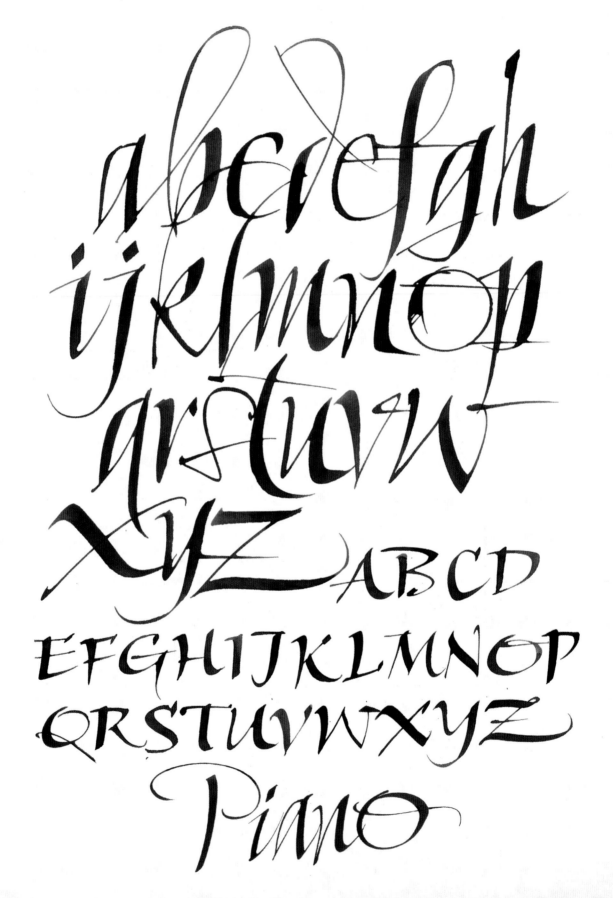

Intertwine

Intertwine is an alphabet of capitals with a fairly light weight (you can adapt them to be heavier or lighter), which I completed with a ruling pen. The appeal of these letters is that you can stack or arrange them in a "lock-up"—a composition that features an interesting form and pattern. In all lettering, the form, rhythm, and movement interact, and the aim is to create an overall pleasing pattern with cascades of movement.

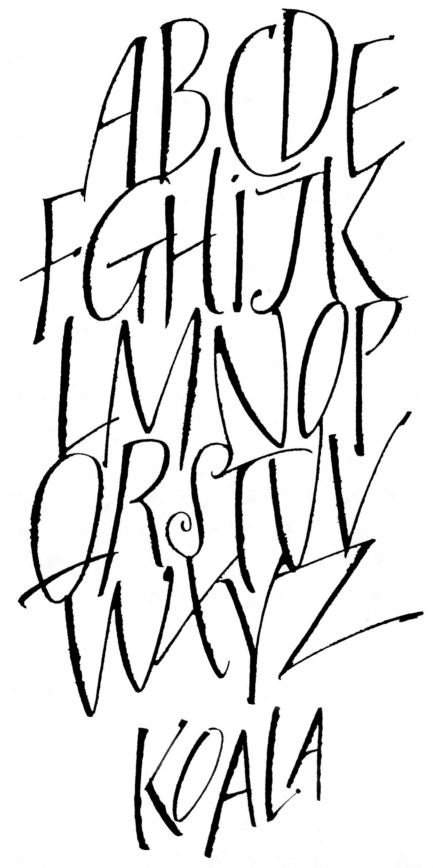

Based on Handwriting

Handwriting is a system made unique by different habits and personalities. Whether loose, illegible, careful, or consistent, each handwriting style says something about its writer.

This section features alphabets that employ strokes similar to handwriting. These strokes have an abundance of movement, and the letters are often joined. Handwritten letters are informal, and no two are the same. There are variations in line weight that do not follow the regularity of formal calligraphy; however, form and rhythm are still important. Alphabets based on handwriting have a loose but controlled quality.

I often use a modified pointed pen for creating lines that are thick in some areas and thin in others, as I want a broad edge with pressure and release capabilities. This is a useful technique in many ways for other types of lettering too. You can create classic lettering styles with this technique as well.

Tool Box

Modified pointed pen
Pointed pen
Pointed brush
Square-cut round-ferrule brush
Felt-tip pen

Boing! Regular

This alphabet can go in several different directions, depending on attitude. It can be viney and *au natural*, it can be busy and quirky, or the lines can be smooth or broken. I created this version with a pointed brush, adding pressure to produce the slight variations in line weight. The letterforms are on the narrow side to allow for the curlicues that encroach on their neighboring letters.

ABCDEFGHI
JKLMNOPQR
STUVWXYZ

abcdefghiijkl
mnopqrstuvw
xyz ANNA

Boing! Heavy

This version of the Boing! alphabet still displays details such as the curlicue and the slightly broken curves, but it is bold and should be written with a pointed brush and a bit of self-involvement. You can create these busy letters in a painterly style, which will emit a look that is both fun and decorative. Your brush technique may vary depending on what paper you use, but you will employ the side and tip. Rough and absorbent papers will render attractive and slightly unpredictable results. Learn to differentiate between the character, the basic structure, and the details that can be changed to suit your taste. Some aspects must be copied, but others can be manipulated.

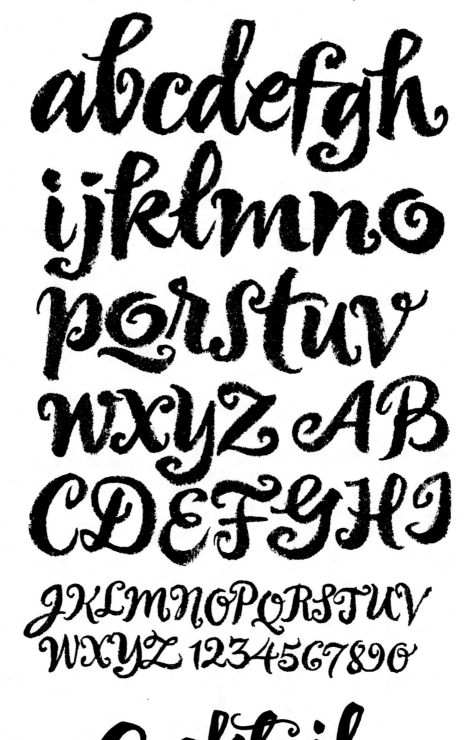

Cheer

I wrote Cheer with a folded ruling pen on rough watercolor paper. This alphabet bears a resemblance to 19th-century scripts but involves taller minuscules. You can experiment with the height ratio of the majuscules and minuscules, but avoid making the minuscules exactly half the size of the majuscules (which I call "avoiding 50-50"). If you have the room, you can elaborate with ascenders, descenders, and the last strokes of a word or group of words. Symmetrical balance is old fashioned, but dynamic balance is full of tension and resolve, resulting in more interest.

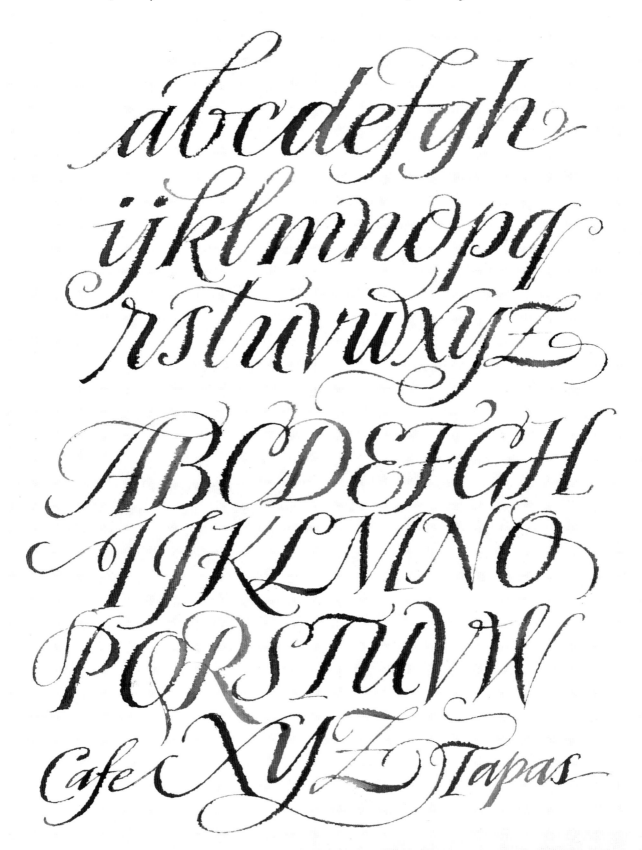

Kaleidoscope

Kaleidoscope is a mix of block letters and the occasional cursive letter. It appears to have more components because the block letters are different weights and sizes. Also, I make the letters very obviously hand-drawn, with no attempt at perfection. As you add color, keep in mind the amount of light and dark, which should balance out for the overall desired look. Otherwise, this alphabet can look too busy. Think 70-30, meaning 70 percent bold and 30 percent light—never 50-50.

ABCDEFGHIJ
KLMNOPQRSTU
VWXYZ

abcdefghij
klmnopqrstu
vwxyz

abcdefghijkl
mnopqrstuvw
xyz

ABCDEFGHI
JKLMNNOPQ
RSTUVWXYZ

ABCDE
FGHIJK
LMNOP
QRSTU
VWXYZ

Latin Quotes

Half of a message can be conveyed through the letters used to create it. This final stage of the lettering process is also the most rewarding. John Stevens constructed the beautifully written Latin phrases below.

Cuiusvis hominis est errare; nullius nisi insipientis in errore perseverare

"Any man can make a mistake; only a fool keeps making the same one."

Lux et Umbra vicissim sed semper amor

"Light and shadow by turns, but always love."

"It is how well you live that matters, not how long."

About the Artists

Cari Ferraro

Cari Ferraro has been practicing calligraphy for more than three decades and has studied with many of the finest calligraphers teaching today. Her design business, Prose and Letters, has fulfilled calligraphy commissions for weddings, corporations, institutions, and individuals since 1982. She also maintains a website as an online portfolio and catalog of her cards, prints, books, and wedding certificates. Cari makes her home in Northern California. www.proseandletters.com

Arthur Newhall

Arthur Newhall had a unique and varied background in the lettering and graphic design fields. His work included type designing, theater lobby displays, movie titles, sign painting, advertising art, lettering for reproduction, and art from screen printing. He also worked as art director for an advertising agency. All of these disciplines added to the refinement of his calligraphy skills. A stickler for precision and style, Arthur was always ready to help and guide the novice as well as the professional. He was one of the innovators of one of the most spectacular letter styles ever created—the Cartoon Casual—as well as a Modern Script of the '40s and '50s. Arthur and his wife, Emma, made their home in Sedona, Arizona, a renowned artist's colony.

Eugene Metcalf

National and international awards punctuated the career of this artist-designer. Eugene's natural talent in various art fields established him as a top calligrapher and designer. Lettering design became a specialty leading him to the creation of logos with a variety of commercial applications. Of his more than 30 years in the commercial art industry, almost half of them were spent as art director and top designer for major outdoor advertising companies in the Los Angeles area. Eugene was a freelance artist in the full spectrum of commercial art, including national magazine covers.

John Stevens

John Stevens is an internationally known calligrapher, designer, and lettering artist with 30 years of experience. An art major and former musician, he found his true calling when he was introduced to lettering while apprenticing in a sign shop. Immediately hooked, he diligently studied letterforms, letterform design, typography, calligraphy, art, and design, scouring libraries to find everything he could get his hands on. John started a business as a freelance letterer and designer in the early 1980s creating lettering, calligraphy, and logo design for publishing companies and other businesses. John's prestigious client list includes *Rolling Stone*, *Time*, *Readers Digest*, and *Newsweek* magazines; Pepsi; Atlantic Records; HBO; Lucasfilm; Universal Studios; Macy's; Bergdorf Goodman; IBM; Disney; and Bloomingdales, among others. Originally from New York, he now lives in Winston-Salem, North Carolina, where he has been a faculty member of The Sawtooth Center for Visual Art and is an exhibiting member of Associated Artists. He also teaches and is the faculty advisor and marketing director at Cheerio Calligraphy Retreats, a biannual retreat in the Blue Ridge Mountains. www.johnstevensdesign.com

Index